IMAGES
of Rail

RAILS AROUND
HOUSTON

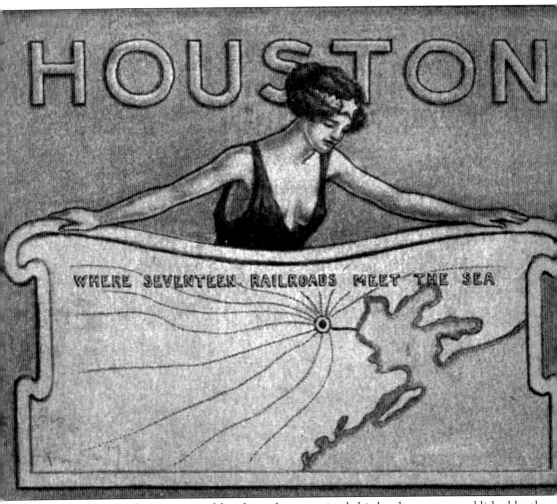

WHERE SEVENTEEN RAILROADS MEET THE SEA

By 1922, when the promotional brochure that contained this lovely map was published by the Houston Chamber of Commerce, Houston could proudly count 17 railroads, although technically they did not all "meet the sea," and one served as the switching line, moving cars between the different railroad yards, and also served the passenger lines of Houston's Union Station. Several lines were also part of the Southern Pacific system. In 1927, with the opening of the Houston North Shore Railroad, it would become "Houston, where 18 Railroads Meet the Sea!" For at least the first half of the 20th century, this slogan could be heard on radio spots and seen in newspaper and magazine advertisements promoting the city. (Courtesy Texas Room, Houston Metropolitan Research Center, Houston Public Library.)

On the Cover: The original caption of this photograph, dated October 22, 1894, of the Houston and Texas Central Railway (H&TC) freight yard, claims that it was taken "without special preparation, just as the yard appeared at that time, after the principal cotton received for the day had been switched to compresses and connecting lines." That is the Magnolia Brewery at the top right. The new three-story Grand Central Depot, serving the H&TC; the Texas and New Orleans Railroad; the Galveston, Harrisburg, and San Antonio Railway; and the Houston East and West Texas Railroads, was just off to the right. (Courtesy Houston Metropolitan Research Center, Houston Public Library.)

IMAGES
of Rail

RAILS AROUND
HOUSTON

Douglas L. Weiskopf

ARCADIA
PUBLISHING

Published by Arcadia Publishing
Charleston, South Carolina

Printed in the United States of America

Library of Congress Control Number: 2008926272

For all general information contact Arcadia Publishing at:
Telephone 843-853-2070
Fax 843-853-0044
E-mail sales@arcadiapublishing.com
For customer service and orders:
Toll-Free 1-888-313-2665

Visit us on the Internet at www.arcadiapublishing.com

*To my dad, James F. Weiskopf, who was working
as a switchman at Englewood Yard the night I was
born, and to all railroaders, past and present*

CONTENTS

ACKNOWLEDGMENTS

The preservers of history are as heroic as its makers.

—Texas governor Pat M. Neff (1871–1952)

I have to begin by acknowledging the author of all beauty, power, and symmetry and His Son and my Savior, Jesus Christ, for the beauty of His creation. Second, I want to thank my wife, Karen, and son, Travis, as well as our friends Mike and Lynn Holder for their unending patience, support, and encouragement and for listening to "trains, trains, trains" for so long. Next, I want to salute my coworkers at Houston Public Library's Scenic Woods Regional Library for taking up the slack when I took extra time off to work on my book and for listening to my stories and looking at my pictures.

Works like this would be nearly impossible if it were not for the historians, archivists, and librarians who have preserved so many pieces of our visual history. Houston Public Library's Texas Room and Houston Metropolitan Research Center (HMRC) are treasure chests of Houston's history. I would like to thank HMRC's manager, Kemo Curry, and their photographer and photo archivist, Joel Draut. Another Texas gem is the Temple Railroad and Heritage Museum (TRHM). Craig Ordner, the archivist there, went out of his way to give me access to the museum's resources. Finally, this book could not have been completed without the help of two men, one of whom I have known and learned from for over 20 years. George Werner allowed me to access his extensive photograph collection and never tired of teaching me and correcting my many errors. The other gentleman I have never met, but when Joel Rosenbaum heard of my plans to write a book on Houston railroads, he offered prompt support and encouragement, lending me wonderful photographs, memorabilia, and articles from his private collection. The members of the Gulf Coast Chapter of the National Railway Historical Society (NRHS) offered constant encouragement and support, but I want to especially thank Bill Willits, Tom Marsh, Phil Whitley, and Paul DeVerter for selflessly sharing their knowledge and resources. Much that is of value in this book I owe to them; the errors are all my own.

INTRODUCTION

From its very beginnings in 1836, Houston was promoted as a "great commercial emporium," and it is now home to the second largest port in the nation. There was no reason for Houston to be here, even as a transportation center, but Houston continued to promote itself as head of navigation on Buffalo Bayou, and by the time oil was discovered near Beaumont in 1901, Houston had grown to such a major railroad and shipping hub that it became the heart of the Gulf Coast petrochemical industry. The importance of railroads in Houston's history is demonstrated by the fact that before there was a steam engine within hundreds of miles, there was a "modern" (for its time) 4-4-0 centered on the city seal, where it remains today.

The Republic of Texas chartered a few railroads, but none was built until ground was broken for the Buffalo Bayou, Brazos, and Colorado Railway (BBB&C) at Harrisburg, near the present location of the Port of Houston Turning Basin in 1851. Aiming to connect the rich plantation bottomlands of those rivers with the natural port at Harrisburg, the BBB&C reached the banks of the Brazos across from Richmond by January 1856. Soon Houston had its own railroad, when the Galveston and Red River Railway (G&RR) began building northwest from Railroad Street on the north bank of Buffalo Bayou. It was slow going, but by July 1856, the G&RR reached Cypress, 25 miles from Houston, and then changed its name to the Houston and Texas Central Railway. When a charter was granted for the railroad to Harrisburg, Houston commercial interests had the legislature grant the city the right to "tap" into the Harrisburg line, which they did, at a place simply called "Junction" in 1856. In 1858, the "tap road" was bought by a railroad being built to serve the wealthy sugar plantations southwest of Houston and became part of the Houston Tap and Brazoria Railway (HT&B). The "tap road" and Peirce Junction would eventually provide both the Southern Pacific and Santa Fe their first route into Houston. Also in 1856, the Galveston, Houston, and Henderson Railroad (GH&H) would begin building toward Houston from Virginia Point on Galveston Bay. In February 1860, a bridge to the island would be completed, connecting Houston and Galveston by rail. Finally construction started in 1857 on what would become the Texas and New Orleans Railroad (T&NO), but it was two more years before much work was done, and in May 1861, the T&NO was finally opened to Beaumont. By the time the Civil War began back east, most of the rail mileage in Texas focused on Harris County; there were four railroads radiating northwest, east, southeast, and south from Houston and the BBB&C building west from Harrisburg.

Although Texas did not suffer the destruction that the older South did in the war, four years of hard use and no maintenance or repairs left Houston's railroads broke and broken. The Galveston and Houston Junction Railroad, which began construction during the war, was an effort to connect the H&TC to the GH&H. The first railroad bridge over Buffalo Bayou and a bridge across White Oak Bayou were completed in October 1865. Within five years, most of the railroads in the area had gone through bankruptcy and reorganization at least once and were building again. The Houston and Texas Central got off to a quick start in 1867, reached Dallas in 1872, and made

a connection with the Missouri, Kansas, and Texas Railway (MKT or "Katy") at the Red River in 1873, giving Houston its first rail connection with the rest of the country. The BBB&C was reorganized as the Galveston, Harrisburg, and San Antonio (GH&SA), becoming known as the "Sunset Route." In 1877, it reached San Antonio as part of the fourth transcontinental railroad, which was completed in January 1883, and "Sunset Route" became the name of the whole line from New Orleans to Los Angeles. Meanwhile, the recovery of the T&NO was especially slow. It reopened in 1870 between Houston and Dayton, about 35 miles, but had to shut down again in just a few months. Finally in 1875, reconstruction began again, and Houston's rail connection with New Orleans finally was achieved in 1880.

The Houston and Great Northern was chartered in 1866 with the grand design of building from Houston to Canada. By 1873, it had purchased the HT&B and built almost 200 miles of track, reaching Palestine, where it joined the International Railroad to become the International and Great Northern (I&GN). When the I&GN connected with the Texas and Pacific at Longview, Houston had another rail link to the north. The next line to be built, Charles Morgan's Texas Transportation Company, although only 7 miles long, gave Houston an actual link with port facilities that could be reached by ships engaged in the coastal trade. The commercial rivalry between Houston and Galveston was intense, with both sensing the importance of a rail network to bring shipping to their ports, and so far, Houston had had the upper hand. Galveston still was dependent on the GH&H, which itself terminated in Houston. Galveston's response was the Gulf, Colorado, and Santa Fe Railway (GC&SF), chartered in 1873 and projected to meet the Denver and Rio Grande in Santa Fe, New Mexico. The GC&SF would cross the GH&SA at Rosenberg and the H&TC at Brenham, bypassing Houston and diverting western trade directly to Galveston's wharves. Headquarters were located in Galveston, where most of the funding came from. Construction began in 1875, but it was four years before 60 miles of track were built. Finally, after foreclosure and reorganization, Fort Worth was reached in 1881. But Houston was not to be denied, and the directors soon realized that even Galveston's railroad needed access to Houston, so a line was built from Alvin up to Houston. To get a shorter route into Houston for its passenger trains, the Santa Fe eventually would obtain trackage rights over the GH&SA from Rosenberg into Houston.

All of this railroad building required much more private capital than was available in Texas, and so the legislature and different cities and counties passed a variety of measures at different times to provide assistance and incentives. Most antebellum roads borrowed money from the Special School Fund, at a rate of $6,000 per mile of track completed, but only one, the HT&B, defaulted. In all, the state loaned almost $2 million but was paid back over $4 million in principal and interest. State land grants were also provided until 1882.

Narrow-gauge fever was also hot in the 1870s, and Houston was not immune. The Western Narrow Gauge Railway was originally conceived and chartered by several prominent Houston businessmen in 1870 to build from Houston to San Antonio, but in 1875, the charter was amended, changing the name to Texas Western Narrow Gauge and giving it authority to build to Presidio on the Rio Grande, then across Mexico, all the way to the Pacific port of Guaymas on the Gulf of California. Unfortunately, only 50 miles of track were ever constructed. Houston's other narrow-gauge railroad, the Houston East and West Texas (HE&WT), was the product of a ghostly admonition but was much more successful. Paul Bremond, who had been one of the forces behind the H&TC, was a deep spiritualist and reportedly claimed to have been visited by the spirit of Moseley Baker, a hero of the Texas Revolution, who urged him to build it. Construction began in 1876. The first train crossed the Sabine River headed for Shreveport in 1886, and it became a part of the short-lived Grand Narrow Gauge Trunk Line that stretched from Toledo, Ohio, through Houston to Sealy, Texas.

All of these different gauges made interchange of freight and passenger cars very difficult. The H&TC, T&NO, and GH&H had originally been built to Texas's "state gauge" of 5 feet, 6 inches, but after the Civil War, 4 feet, 8.5 inches became the "standard" gauge of American railroading. Although the H&TC advertised through Pullman Palace cars to St. Louis and bragged that

they could change the trucks on a freight car in three and a half minutes, shippers began to complain about the delays. The T&NO changed gauge during its rebuilding in 1876; the H&TC made the conversion in three different monumental one-day efforts in 1874, 1876, and 1877. The GH&H also standardized its gauge at the same time as the H&TC in July 1876. Exactly 18 years later, in July 1894, the HE&WT was converted from 3-foot to standard gauge in one day along its entire length.

Railroad construction continued to boom through the first decade of the 20th century. The San Antonio and Aransas Pass Railway (SA&AP) reached Houston in 1887, providing a direct rail link to Corpus Christi and another line to San Antonio. Finally in 1893, the Katy (MK&T of Texas) built its line into Houston, giving Houston another link to San Antonio, to Waco, and to points north. In 1903, the I&GN completed a direct connection from their mainline at Spring, just north of Houston, to Fort Worth. In 1907, the Beaumont, Sour Lake, and Western (BSL&W) and the Trinity and Brazos Valley (T&BV) reached Houston. The BSL&W provided another connection to Beaumont and railroads to the east, while the T&BV provided a shorter route to Dallas and north Texas. In 1909, the St. Louis, Brownsville, and Mexico (St.LB&M) opened a more direct route from Houston to the Rio Grande Valley.

Texas law and the Texas Constitution of 1876 had required that railroads operating in Texas be headquartered here, and this held firm until a U.S. Supreme Court decision in the 1930s gave the Interstate Commerce Commission (ICC) final authority. Railroad consolidation took hold in the 1880s, with larger systems simply controlling the Texas corporate entities in different ways. The Southern Pacific (SP) controlled the GH&SA and T&NO by the time the silver spike was driven just west of the Pecos River to complete the "Sunset Route," the first transcontinental railroad under one management. In 1883, SP interests gained control of the H&TC, the little Texas Transportation Company, and other lines by purchasing Charles Morgan's Louisiana and Texas line. By the turn of the 20th century, the SA&AP and HE&WT were also under SP control. In 1887, the Atchison, Topeka, and Santa Fe Railroad had taken over the GC&SF. By the mid-1920s, the I&GN, BSL&W, and St.LB&M were brought into the Missouri Pacific system. Finally, the T&BV was bought by the Colorado and Southern Railway (C&S), which turned around and sold half interest to the Chicago, Rock Island, and Pacific Railroad, giving them access to Houston. Then the Chicago, Burlington, and Quincy swallowed up the C&S in 1909.

As Houston grew and its port facilities became more extensive, several short lines and terminal switching lines were started. The Houston Belt and Magnolia Park Railway was chartered in 1889 to connect downtown Houston with the Long Reach docks on the Ship Channel and eventually became part of the I&GN. It is now mostly abandoned and turned into bike trails. In 1916, the City of Houston built the Municipal Harbor Belt Railroad to serve the port. It was eventually taken over by the Navigation District and became part of the Port Terminal Railroad Association, organized in 1924 to provide switching services to all railroads serving the port. B. F. Yoakum had put together a system challenging SP dominance in much of south and east Texas, reaching down into the Rio Grande Valley, up into north Texas, and to New Orleans. In 1905, he chartered the Houston Belt and Terminal Railroad (HB&T) to handle freight and passenger terminal operations for his three Houston railroads—the St.LB&M, BSL&W, and T&BV—with the GC&SF joining for one-quarter ownership as well. HB&T would operate Houston's Union Station for over 60 years and provide freight switching and engine facilities for its owning railroads for over 75 years.

Houston's street railway system began in 1868 with mule-drawn streetcars, which were electrified in 1891 and provided light rail transportation to a booming city for almost 50 years. Houston was also home to two interurbans. The Galveston-Houston Electric Railway's elegant cars provided quick, convenient transportation to Galveston from 1911 to 1936. Proclaiming "Speed with Safety," it was recognized for several years as providing the fastest interurban schedule in the United States. Houston's other electric railway, the Houston North Shore, chartered in 1925 to serve eastern Harris County, holds the distinction of being the last interurban constructed in the country. There was even a monorail exhibited on South Main Street in the 1950s and some

efforts to have one installed connecting Houston's Astrodome and Astroworld (and also at Hobby Airport), but they died for lack of interest.

When first built, railroads offered the ultimate in speedy and comfortable travel. As development continued, railroads advertised the ease of traveling to St. Louis, Chicago, Kansas City, San Francisco, or New York without change of cars, and by the 1920s, Houston's web of rail connections made it possible to travel to, or ship packages to, almost any spot in the country. Railroads responded to the competition of highways and airlines by developing faster, lightweight trains, leading the way in melding art and industrial design to produce sleek streamliners. Thirty trains a day stopped at Southern Pacific's Grand Central Station and at least 32 at Union Station. Travelers to Dallas had their choice of the SP's *Sunbeam* or the Burlington's *Sam Houston Zephyr*, which offered "mile a minute" service in exciting races every day. But eventually the speed of jets and convenience of the automobile won out and passenger trains almost disappeared, until now only Amtrak's *Sunset Limited* and a bus connection with the *Texas Eagle* serve Houston.

Trucks on highways also cut into freight traffic, and railroads responded with larger and innovative freight cars and systems, and by consolidating and abandoning routes, until the 18 railroads that had met the sea in 1930 had dwindled to six by 1980, down to three by 2000. The Missouri Pacific, Missouri-Kansas-Texas, and even the once-dominant Southern Pacific are all part of the Union Pacific now. With abandonment and consolidation came new challenges of gridlock and congestion, but rail traffic is growing again, and new lines are being built, trying to deal with the challenges presented by more and longer trains moving potentially hazardous materials. Houston moved into the 21st century with the beautiful black, red, and yellow of the Kansas City Southern rebuilding abandoned track and opening new transportation vistas.

One

BEGINNINGS

Houston was founded by Augustus and John Kirby Allen, a pair of enterprising New Yorkers who had come to Texas to make their fortune. On August 30, 1836, they began advertising town lots for sale in what was to be the "great commercial emporium of Texas" at the "head of navigation" on Buffalo Bayou. Navigable year-round for at least 50 miles inland, the bayou was the highway for planters to ship their products to market and receive imports from around the world. Trade was the name of the game, and the first Houstonians set out to make their dream reality. Railroads were the key to securing trade, so when Houston's city seal was adopted in 1840, it featured the latest development in railroad technology, a 4-4-0 American-type locomotive, right in the center. In the race for a railroad charter on Buffalo Bayou, Houston struck first, when Texas president Mirabeau B. Lamar signed a charter for the Houston and Brazos Rail Road Company in January 1839. It provided for an improved road using "all kinds of boats, vehicles, wagons or carriages of any nature," connecting Houston and the Brazos Valley.

Houston's rival, Harrisburg, an established port a few miles downstream, had been settled in 1826 but was burned to the ground by Santa Anna. On January 5, 1840, the Harrisburg Town Company set aside 352 town lots as the basis of a "railroad fund" until a charter could be obtained. In 1841, the Harrisburg Rail Road and Trading Company was chartered by Andrew Briscoe to build that railroad, but there was too much land and not enough capital for the sale of town lots to pay for a railroad in Texas. In 1846, Sidney Sherman moved to Harrisburg, became interested in promoting trade, and set out for Boston in search of money. In February 1850, he and a group of Boston investors were granted a charter for the Buffalo Bayou, Brazos, and Colorado Railway. And on Christmas Eve 1852, the first locomotive in Texas, the *General Sherman*, was fired up, built a head of steam, and whistled that the railroad age had begun in Texas!

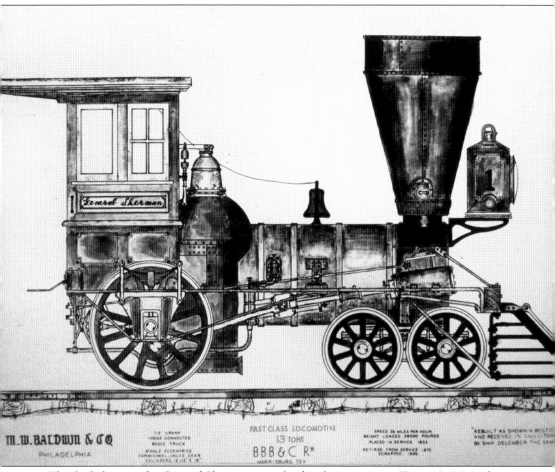

This little beauty, the *General Sherman*, was the first locomotive in Texas. A 4-2-0 of uncertain lineage, she was built by Baldwin Locomotive Works sometime between 1836 and the early 1840s and purchased secondhand in Boston for $3,250 by the Buffalo Bayou, Brazos, and Colorado Railway. She weighed 12.5 tons and had 54-inch driving wheels and 12.5-inch cylinders. President of the BBB&C Jonathon Barrett declared she "could reach a speed of 35 miles per hour, should any contingency call for it." She arrived in Harrisburg in 1852, having been named for Gen. Sidney Sherman, a hero of the Battle of San Jacinto and a founder of the BBB&C. First fired up December 24, 1852, and first run February 9, 1853, she served the railroad well and was taken out of service in 1870. This drawing is by J. E. Loeffler, an amateur historian whose lifelong passion was to document the early motive power of the BBB&C. (Courtesy HMRC, HPL.)

Gen. Sidney Sherman was captain of a Kentucky volunteer militia company when he became interested in the fight for Texas independence. He raised and equipped a company of 52 men and headed for Texas, bringing with him the only flag and artillery the Texian army had at the Battle of San Jacinto. Eager for a fight, General Sherman began the attack and is credited with the cry "Remember the Alamo!" As Texas grew, Sherman was one of the first to realize the need for outside capital to fund improvements. He traveled to Boston in 1847, where he met with financiers, including Jonathon F. Barrett, to solicit their support for a railroad from Harrisburg to the Brazos River. The Buffalo Bayou, Brazos, and Colorado Railway charter was issued in 1850, with Barrett as its first president. (From May–June 1951 *SP Bulletin*, author's collection.)

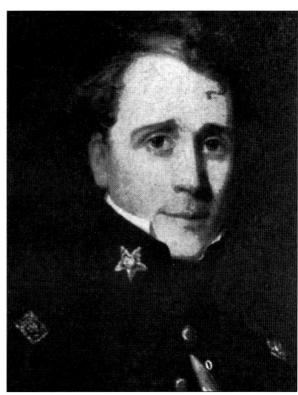

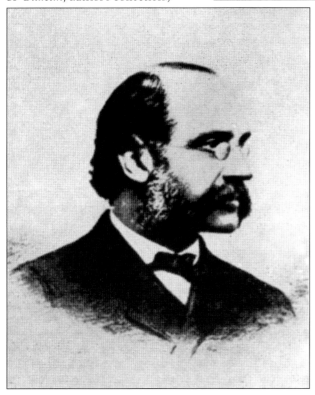

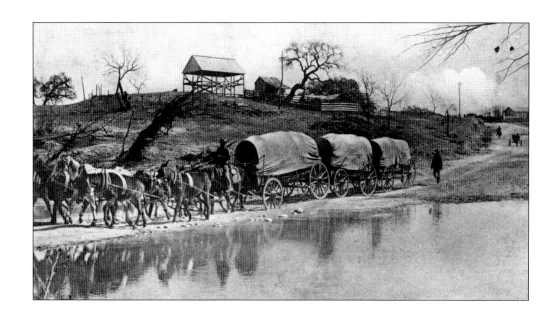

Freight transportation before the railroads meant hundreds of wagons and thousands of teams of oxen or mules trying to haul heavy loads over muddy roads—at an average cost of 1¢ per 100 pounds per mile. The above image shows a train of freight wagons pulled by mules west of Houston. Moving bulky cargo, like cotton or sugar cane, the primary cash crops in the area, added more complications. Wagons, like those in the drawing below from the 1875 book *The Great South*, could carry no more than 10 bales, usually averaged only six, and could make only four trips in a given season. In 1855, the *Houston Telegraph* reported that in one week, 670 wagons pulled by 4,690 oxen delivered 4,000 bales of cotton to town. (Above author's collection; below courtesy Texas Room, HMRC, HPL.)

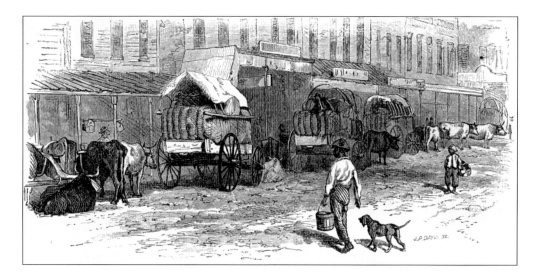

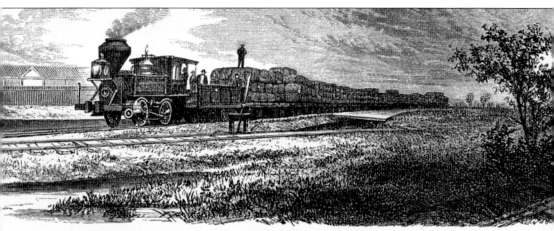

"The cotton train is already a familiar spectacle on all the great trunk lines."

This sketch of a cotton train in 1875 also appeared in *The Great South*. The locomotive is probably the Houston and Texas Central's *Bison*. The huge diamond smokestack on these beautiful wood burners was to catch the inevitable sparks they produced, and many were said to produce their own fireworks at night. A cotton fire was almost impossible to extinguish, so often the locomotives would push their trains of fluffy tinder. Since that is not the case here, the extra men riding in the tender and brakeman standing atop the cotton bales would have been watching for any smoldering embers from the smokestack before they could set the load on fire. In contrast to a wagon carrying only a few bales, here is one train carrying hundreds of bales. In 1877, the H&TC alone carried over 300,000 bales of cotton! (Courtesy Texas Room, HMRC, HPL.)

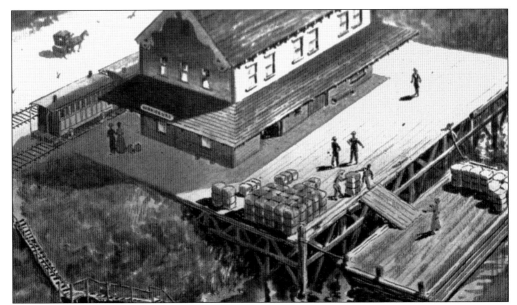

This is an artist's rendering of what the first railroad depot in Texas would have looked like shortly after the Buffalo Bayou, Brazos, and Colorado opened for business. An early annual report stated that the depot was built right on the edge of Buffalo Bayou and connected to a wharf for "the landing and shipment of freight directly to and from the boats on the bayou." (From May–June 1951 *SP Bulletin*, author's collection.)

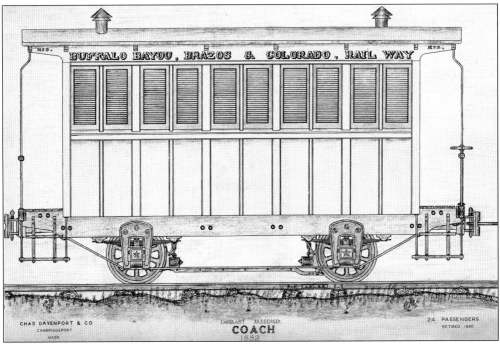

This drawing by J. E. Loeffler, based on his research, depicts an early "emigrant passenger coach." It was only about 30 feet long and had benches that stretched lengthwise along both sides of the car. They were not secondhand streetcars, as is sometimes reported, although the four-wheel design was obsolete by 1850. (Courtesy HMRC, HPL.)

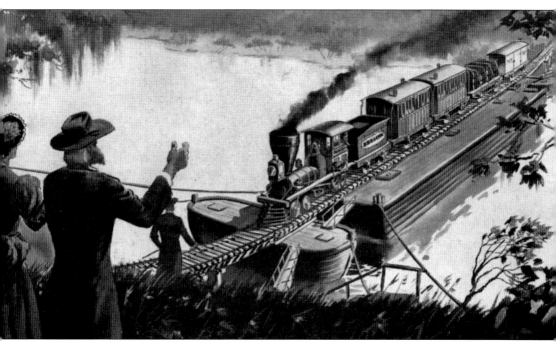

There were 65 bridges in the first 70 miles of the BBB&C, but the Brazos River was a special challenge. The first bridge, built in 1856, was only 6 feet above the low-water level. To allow for steamboats to pass the center section was a 50-foot-long flatboat that could be moved aside. The approaches were very steep, so in order to have enough momentum, a train literally had to speed down one bank and race across the floating center section. Passengers were given the option of getting off and walking across the bridge first. A passenger wrote, "The engine began snorting and puffing and in a few minutes it literally plunged across the rickety bridge. Anyhow, it made it in fine fashion . . . came to a screeching stop and my father and I . . . climbed aboard." In a scene that was repeated twice a day, six days a week, the *General Sherman* pulls a mixed train across the flatboat-bridge while onlookers enjoy the excitement. (From May–June 1951 *SP Bulletin*, author's collection.)

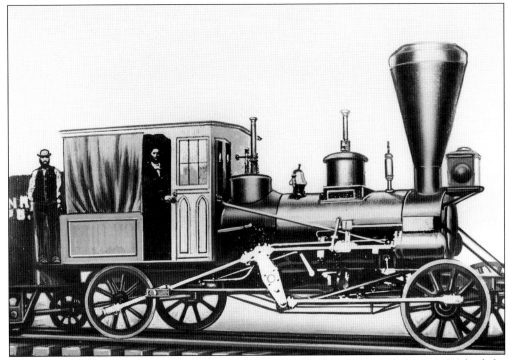

The BBB&C's second locomotive, purchased in 1856, was the *Texas*, a 12.5-ton 0-4-0 built by Boston builder Seth Wilmarth. Small driving wheels, only about 34 inches in diameter, gave her great pulling power, but a long wheelbase gave her a tendency to derail on most curves. She was quickly retired and sold for stationary use. This image is of a very similar locomotive. (Courtesy George C. Werner Collection.)

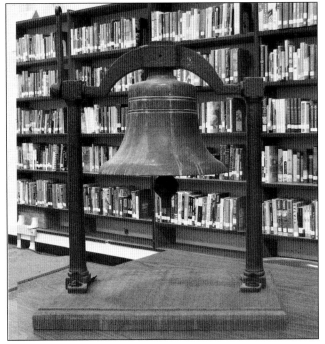

Thankfully the bells from both the *General Sherman* and the *Texas* have been preserved. This is the *Texas*'s bell, which was saved by Mary Tod Hamner and now is on permanent display in the library of Milby High School in Harrisburg. Col. C. Norris Posehn, who commanded the Army ROTC there, took care of the bell and provided for its display. (Photograph by the author.)

Houston's city seal was adopted when locomotives in Texas were still a dream more than a decade from fulfillment. Mayor Francis Moore had it carved for him while on a trip to New York City, then brought it back and presented it to the city council, which adopted it as the official seal of the City of Houston on February 24, 1840. (Courtesy Texas Room, HMRC, HPL.)

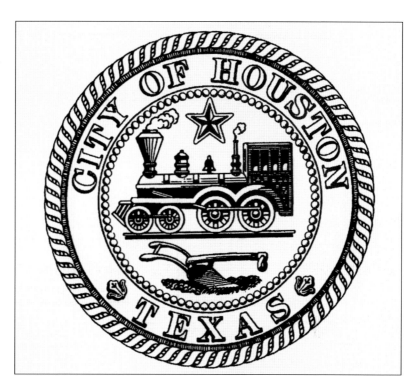

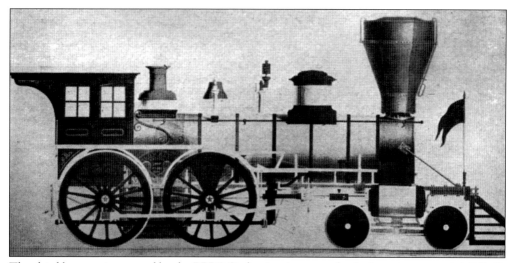

The third locomotive owned by the BBB&C, the *Austin*, was a classic American-type 4-4-0. Built in 1854 by the Lowell Machine Shop in Lowell, Massachusetts, she had 54-inch driving wheels and 12-by-20-inch cylinders; *Austin* served the BBB&C and later the Galveston, Harrisburg, and San Antonio until 1884. This picture depicts a sister locomotive made by the same builder at the same time of similar dimensions. (From May–June 1951 *SP Bulletin*, author's collection.)

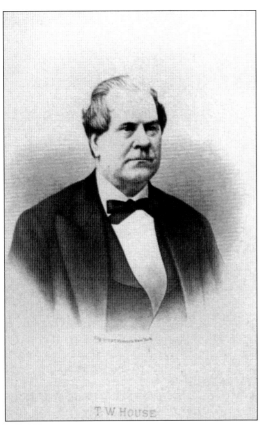

Thomas William House was born in England in 1814, opened a bakery in Houston in 1838, and started a bank in 1840. He gradually built a huge business as commission merchant and cotton factor. He was involved in improving bayou transportation and a founder of the H&TC and the first Houston street railway, and he also helped rebuild the T&NO in 1875. (Courtesy Texas Room, HMRC, HPL.)

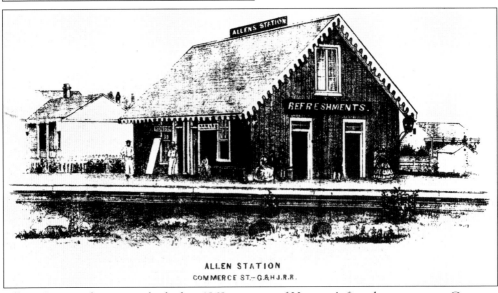

ALLEN STATION
COMMERCE ST.–G.&H J.R.R.

Allen's Station, shown as it looked in 1869, was one of Houston's first depots, was on Congress Avenue, just east of downtown. It served the Galveston, Houston, and Henderson and the Galveston and Houston Junction Railroads. It may be named for Ebenezer Allen, one of the founders of the H&TC, or D. O. Allen, a superintendent of the GH&H. (Courtesy Texas Room, HMRC, HPL.)

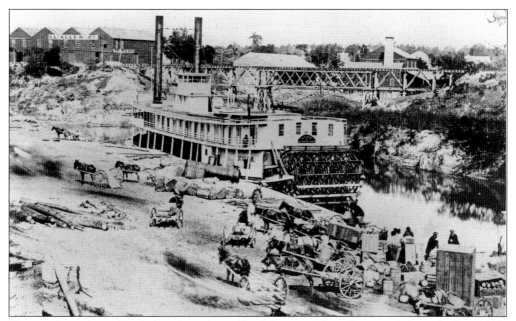

This is where the railroads first "met the sea" in Houston. This photograph from the late 1860s depicts the stern-wheel steamboat *St. Clair* unloading cotton. In the background can be seen the new bridge of the Galveston and Houston Junction Railroad crossing White Oak Bayou. When railroad development began, the Port of Houston was centered at "Allen's Landing," right downtown at the foot of Main Street. (Courtesy HMRC, HPL.)

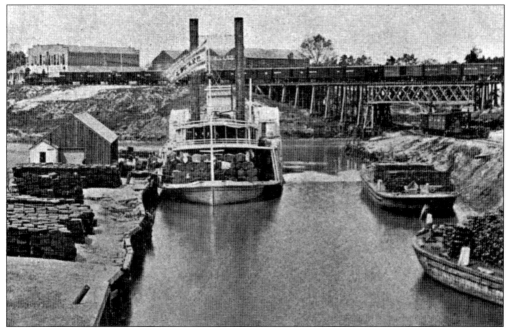

Here is "Allen's Landing" again, the same location as the photograph above, but it is about 10 years later. Here we see the *Lizzie* and some barges loaded with cordwood and cotton. The freight train is possibly pulled by the busy little H&TC *Bison* on the G&HJ bridge over White Oak Bayou, and another locomotive spots cars next to the bayou wharves. (Courtesy HMRC, HPL.)

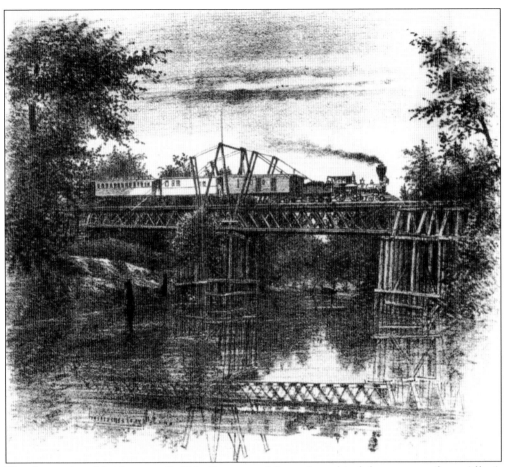

The first railroad bridge over Buffalo Bayou, and first of any kind downstream from Allen's Landing, was located just northeast of downtown in an area known as "Frost Town." None of the four railroads radiating out of Houston connected with another, which meant everything shipped through town had to be unloaded, carted to a different terminal, and reloaded. The Galveston and Houston Junction Railroad was chartered in 1861, and the Confederate government pushed hard to get it built and gain direct access to the port at Galveston, but it was not to be finished until the war was over. In October 1865, a timber Howe truss bridge over White Oak Bayou and a 186-foot swing bridge over Buffalo Bayou were completed and the G&HJ RR opened to connect the Houston and Texas Central Railway with the Galveston, Houston, and Henderson. Trains could finally travel all the way from the cotton fields of Central Texas to the Port of Galveston. This, the only known picture of the first Buffalo Bayou bridge, was published in 1869. (Courtesy Texas Room, HMRC, HPL.)

This idyllic scene depicts the second railroad bridge built across Buffalo Bayou, less than a mile from the G&HJ bridge, around 1873. This allowed the International and Great Northern to connect with the GH&H and the Houston Tap and Brazoria. Because steamboat traffic was still active on the bayou, it also was built as a swing bridge. (Courtesy Texas Room, HMRC, HPL.)

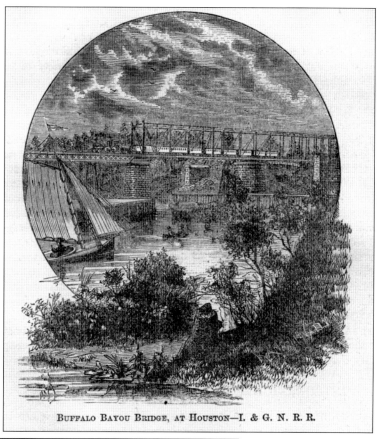

BUFFALO BAYOU BRIDGE, AT HOUSTON—I. & G. N. R. R.

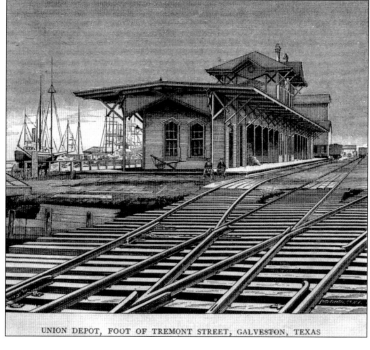

UNION DEPOT, FOOT OF TREMONT STREET, GALVESTON, TEXAS

The impressive and lightly delicate Galveston Union Depot, featured in the *Southern and Western Texas Guide for 1878*, was probably the first depot for the Gulf, Colorado, and Santa Fe in Galveston. It was located at the foot of Tremont Street on the Galveston wharves, just three blocks from where today's Galveston Railroad Museum is housed in the 10-story, art deco Union Station, built in 1932. (Courtesy Texas Room, HMRC, HPL.)

THE GREAT CENTRAL ROUTE!!

Your Route to the North, East and West

IS VIA THE

Houston & Texas Central

RAILWAY,

CONNECTING WITH THE

Missouri, Kansas & Texas Railway

AT RED RIVER CITY.

Giving an All Rail Line to

CHICAGO,	BOSTON,
BALTIMORE,	CINCINNATI,
WASHINGTON CITY,	NEW YORK,
PHILADELPHIA,	SAINT LOUIS,

And All Prominent Points North, East and West,

Pullman Palace Drawing Room and Sleeping Cars,

Run through from

HOUSTON TO ST. LOUIS AND CHICAGO WITHOUT CHANGE.

Baggage Checked to all Prominent Points in the United States

AND CANADAS.

Through tickets sold at Houston, Austin, Hempstead, Bryan, Calvert, Waco, Corsicana, Dallas, McKinney and Sherman, via Red River City and Galveston, to all points of note between the Atlantic and Pacific Oceans, within the limits of the United States and Canada. Also via stage lines to San Antonio and Weatherford.

For through rates apply to Station Agents, or **J. DURAND,**
J. WALDO, Gen'l Freight and Ticket Agent. General Superintendent.

This enticing advertisement is from *All about Texas and the Great Southwest*, a railroad guide published in Houston in 1875, by W. N. Bryant. An H&TC "express" train could reach the Red River in just 18 hours. Another advertisement in the same book crowed "Good News to All" about the "Pullman Palace Drawing Room and Sleeping Cars" on the "Lone Star Route" of the I&GN to all points in the North, East, and West. Houstonians now enjoyed two different options in reaching St. Louis, Chicago, or other eastern cities in only a few days of relative comfort. Courtesy Texas Room, HMRC, HPL.)

This drawing, called "Going to Texas," shows the interior of a typical railroad coach from around 1875. Compared to the other options of the day (stagecoach, wagon, or walking), a large open coach, with padded seats, room to move around, rudimentary lighting and heating, water to drink, and even a rudimentary restroom, railroads offered great improvement. (Courtesy Texas Room, HMRC, HPL.)

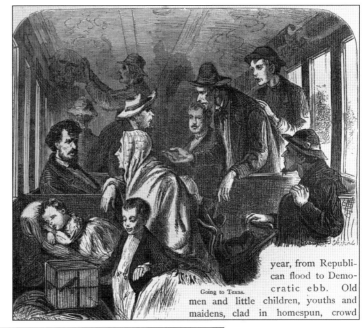

year, from Republican flood to Democratic ebb. Old men and little children, youths and maidens, clad in homespun, crowd

Going to Texas.

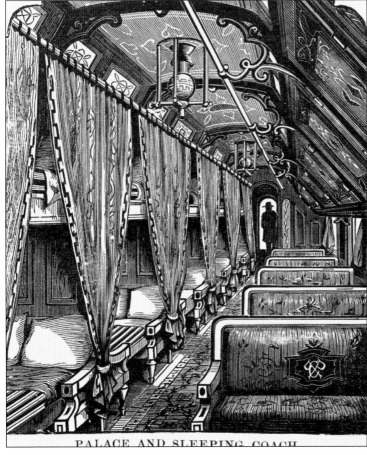

PALACE AND SLEEPING COACH

This illustration shows the finest sleeping accommodations available for those who could pay extra fare, as advertised on the previous page. The seats on the right are arranged for daytime travel, but in the evening, a porter would fold the seats down to form the lower bunk and pull down the ceiling panels to form the upper bunk, with heavy curtains for privacy. (Courtesy Texas Room, HMRC, HPL.)

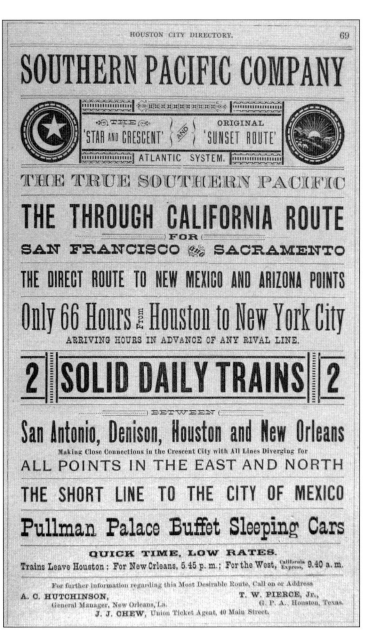

Morrison and Fourmy, publishers of the *General Directory for the City of Houston*, must have used every different print type they had for this busy and very important looking proclamation of the "True Southern Pacific" in their 1886–1887 edition. The California SP's "Big Four" have joined Thomas Peirce to become the Big Five and complete their transcontinental railroad through San Antonio and Houston all the way to New Orleans, and the SP now has an "Atlantic System." The T&NO's Star and Crescent route east to New Orleans, the Galveston, Harrisburg, and San Antonio Railway's newly opened Sunset Route transcontinental line to El Paso and all the way to San Francisco, and even a connection to Mexico are now all part of the Southern Pacific Company. The Texas Constitution briefly still required all Texas railroads to be headquartered here, but consolidation would be achieved through an "Omnibus Lease," which took effect in March 1885 but only lasted until it was overturned in 1889. (Courtesy Texas Room, HMRC, HPL.)

Two

THE SUNSET ROUTE

The term "Sunset Route" was first applied to the Galveston, Harrisburg, and San Antonio Railway as early as 1874. Although no one knows the origin of the nickname, one story has it that when the end of the track was at Alleyton and there was one train a day in each direction, the train would leave Harrisburg in the morning and not reach Alleyton until sunset. At any rate, as the Southern Pacific completed its transcontinental line, it became known as the "Sunset Route" and their deluxe all-Pullman train the *Sunset Limited.*

To safeguard and feed its latest transcontinental line, the SP quickly gained control over several of the early railroads that had been built from Houston. Central Pacific's Big Four controlled the Galveston, Harrisburg, and San Antonio by 1877, and they took control of the Texas and New Orleans in July 1881. They had also gained control of the Louisiana Western Railroad, which connected with the T&NO, and by 1883, they had bought control of Morgan's Louisiana and Texas Railroad and Steamship Company. ML&T had already sold the Texas Transportation Company to the SP, although it would be operated separately until 1896. In 1885, the Omnibus Lease would bring most of these lines directly under SP control, but this was abrogated in 1889, and until 1927, most of the SP's properties would be organized into the GH&SA, the T&NO, and the H&TC. The H&TC and the Houston, East and West Texas, which came under SP control in 1899, would continue to retain some independence, however, and would be the only SP lines in the "Atlantic System" (Texas and Louisiana) still lettering their own equipment and numbering their locomotives separately. As the power of the ICC to regulate railroads increased, the Texas constitutional requirement of local ownership lost enforceability. In 1927, the SP's major Atlantic Lines were leased to the T&NO; then in 1934, they were formally merged. In 1961, the T&NO was merged into the Southern Pacific Company.

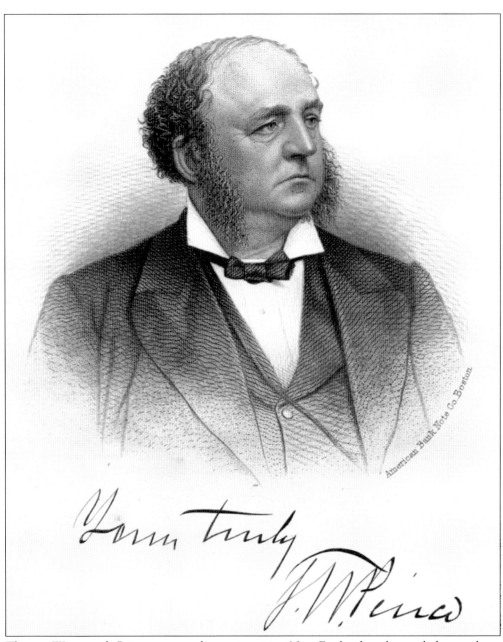

Thomas Wentworth Peirce was another enterprising New Englander who made his mark on Houston's railroad history. He established his mercantile house in Boston in 1843 and opened a Galveston branch in 1852. He bought a large Fort Bend County sugar plantation, and by 1857, he was a director of the H&TC and involved in the BBB&C. In 1868, Peirce, Jonathon Barrett of Boston, and John Sealy of Galveston purchased the BBB&C in a sheriff's auction. In 1870, the BBB&C was reorganized and the name changed to the Galveston, Harrisburg, and San Antonio Railway. Peirce was named president and began pouring money and time into its expansion. While he was also involved with the GH&H, Peirce focused mainly on the GH&SA, making it an important link in the SP's transcontinental line and building a branch to Eagle Pass with a rail link to Mexico. (Courtesy Texas Room, HMRC, HPL.)

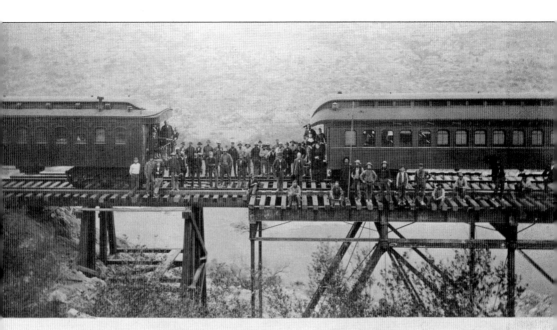

E DRIVING OF THE LAST SPIKE ON THE GREAT SOUTHERN PACIFIC R. R., JANUARY 12, 1883

The GH&SA reached San Antonio in 1877. In 1880, Thomas Peirce joined forces with the Southern Pacific's Big Four to form the Southern Development Company and complete a southern transcontinental railroad along the GH&SA's Sunset Route. Surveying began in April. Building east from El Paso and west from San Antonio, construction parties met just west of the Pecos River, where Colonel Peirce drove a silver spike on January 12, 1883. Peirce commemorated the event with a speech in which he spoke of "the majestic presence of these great canyons of the Rio Grande, which impress and awe me with the majesty of great Jehovah . . . and on the other hand of man's significance in his great triumphs over the forces of nature . . . May God in His Providence make this great work rebound to the interest, comfort, and civilization of mankind." As if in answer to Peirce's prayer, on January 31 the first westbound sleeping car passed through Houston, with first-class passage to California selling for $85.45. (Courtesy Texas Collection, Baylor University.)

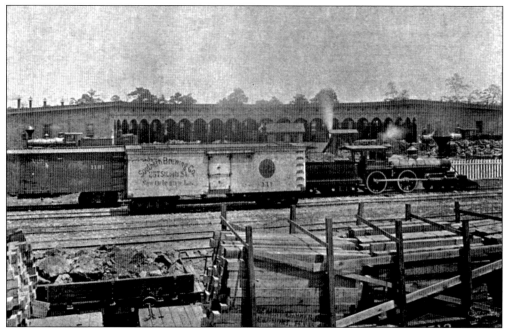

Located deep in Houston's Fifth Ward, just north of downtown, this was originally the Texas and New Orleans Railroad's shop facilities. When the Galveston, Harrisburg, and San Antonio moved their shop facilities to Houston in 1888, they were located here as well. This beautiful 4-4-0 burned coal, had drivers of approximately 60 inches, and weighed about 70,000 pounds. (Courtesy Texas Room, HMRC, HPL.)

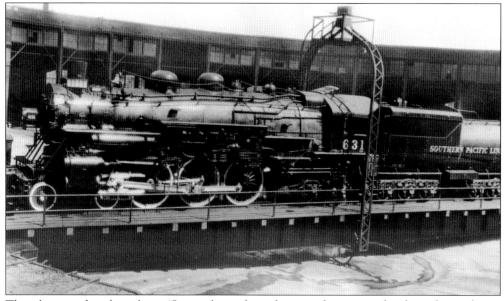

This photograph, taken about 45 years later, shows how much steam technology changed over the first quarter of the century. No. 631 is a P-13 class Pacific (4-6-2), the heaviest of their wheel arrangement the SP owned in Texas. She was built by Baldwin Locomotive Works in 1928 with 73-inch drivers, 25-by-30-inch cylinders, was equipped with a 16,000-gallon tender, and weighed approximately 313,000 pounds. (Courtesy HMRC, HPL.)

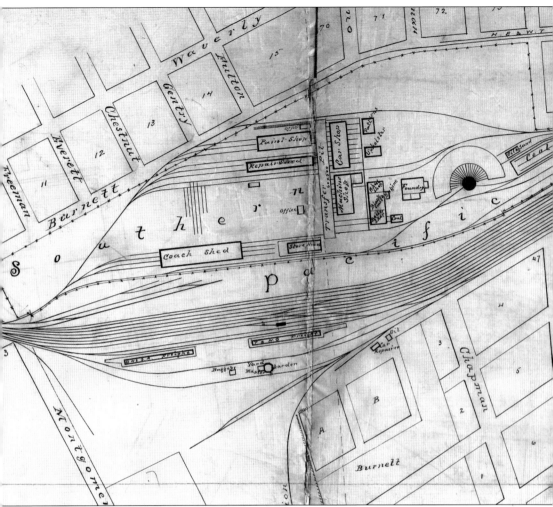

This map, just one section of a huge detailed map drawn for the H&TC in November 1888 of SP Rail facilities and connections with other lines, shows the layout of the shops and roundhouse on the previous page. Montgomery Road on the left side is today North Main Street, and Hardy and Elysian Streets are the next two blocks to the right after McKee Street. This was a heavy industrial facility, capable of rebuilding and even building railroad cars and even locomotives. This area will eventually become known as the Hardy Street Shops. It will be the principal locomotive maintenance and construction facility for the SP in southeast Texas and will remain in use until finally abandoned by Union Pacific after their takeover of the SP. (Courtesy Temple Railroad and Heritage Museum.)

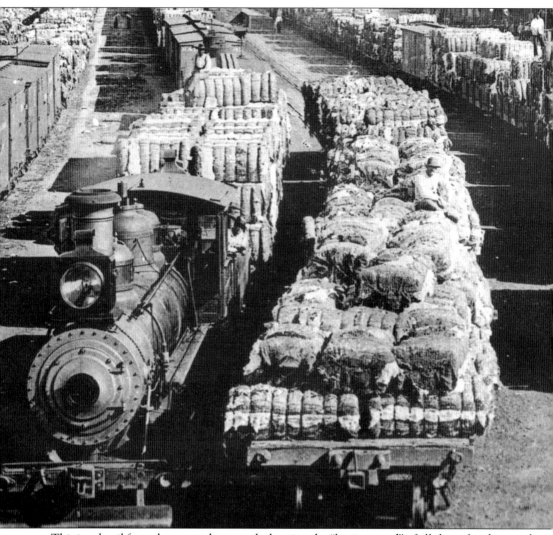

This is a detail from the cover photograph showing the "business end" of all those freight cars that have to be coupled together to make a train. The coupler pockets are the large box-like openings at the end of each car. To make up a train, each car had to be connected to the next by inserting a link, like an elongated link of a very heavy chain, such as the one seen in the coupler pocket on the locomotive, then dropping the pin, which is seen sticking out of the coupler pocket at the end of the flatcar next to it. The hitch is that, to do that, the brakeman had to stand between the cars as they were being moved together, line the link up with the coupler pocket, and drop the pin in at just the right moment. When a man applied for work as a brakeman, if he didn't have any missing fingers, it was assumed he had not worked for long. (Courtesy HMRC, HPL.)

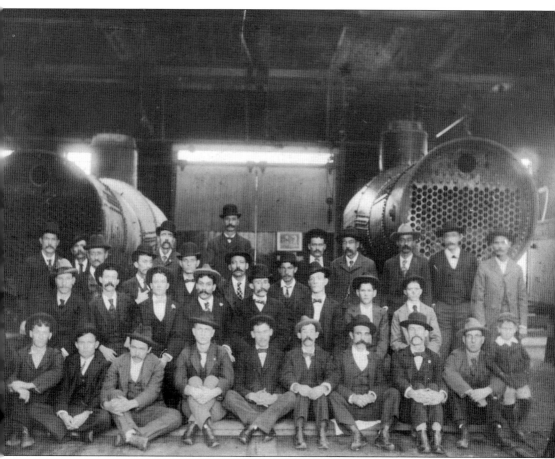

Even though the SP controlled the Houston and Texas Central after 1883, for several years, it was treated as its own separate company, and its equipment was still lettered for the H&TC. These dapper gentlemen are the H&TC Boiler Shop crew in October 1898. Here they are posing behind two boilers under construction; all of those little holes are the openings of the boiler tubes. Smoke and heat from the fire in the firebox is pulled through them, heating the water in the boiler to create steam. As the steam is exhausted from the cylinders, it is fed up the smokestack, creating a vacuum that pulls the heat and fumes through the boiler tubes even faster and causing a draft that makes for a hot fire. (Courtesy HMRC, HPL.)

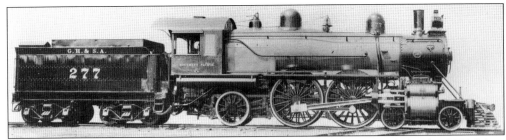

This is the Baldwin builder's photograph of class A-1 Atlantic No. 277, built for the GH&SA in 1903, with high stepping 84-inch drivers. These were Vauclain compound engines, which meant that the steam first went to the smaller cylinder under higher pressure, then was exhausted to the larger cylinder below it, where it could expand again and its power be used twice. (Courtesy Texas Collection, Baylor University.)

This beautiful A-3 class Atlantic-type locomotive (4-4-2) was built by the Schenectady Locomotive Works in 1904. She had 73-inch drivers and 20-by-29-inch cylinders, weighed almost 200,000 pounds, and developed a total tractive effort of 23,500 pounds on a boiler pressure of 200 pounds of steam. This photograph is from a promotional book put out by the Texas Company in 1912, entitled *Oil Fuel*. (Courtesy Texas Room, HMRC, HPL.)

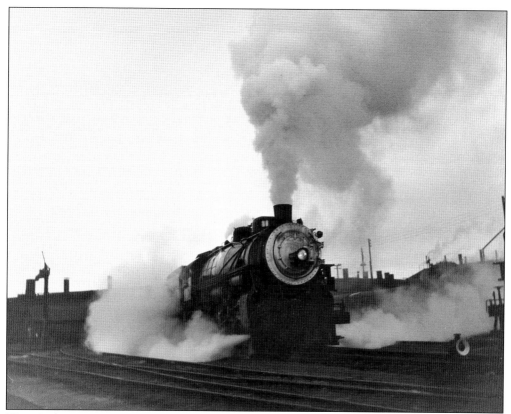

T&NO class P-9 Heavy Pacifics could handle most passenger trains in southeast Texas. No. 630 is putting on a show for the photographer as she leaves the "ready tracks" at SP's Hardy Street facility. This beauty was built by Baldwin in 1923, had 25-by-30-inch cylinders, and operated on 210 pounds of boiler pressure. (Courtesy TRHM, Joe Thompson Collection.)

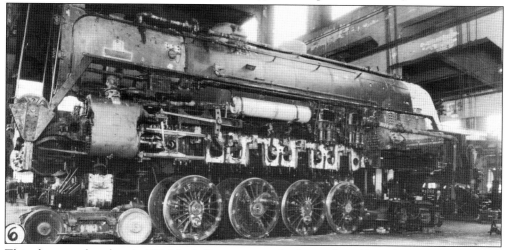

This photograph, taken in SP's Hardy Street engine facility in June 1940, shows a massive GS-1 type 4-8-4 being rebuilt. The 4-8-4 wheel arrangement is generally called a Northern type, but the SP called theirs Golden State, or General Service. Built for hauling long, heavy passenger trains over steep grades, these locomotives were more common out west. (Courtesy HMRC, HPL.)

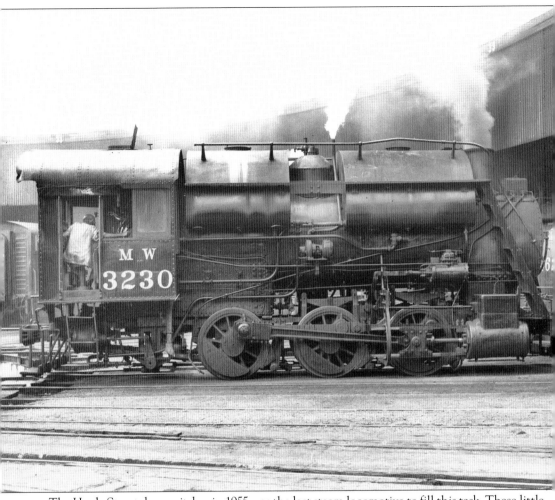

The Hardy Street shop switcher in 1955 was the last steam locomotive to fill this task. These little brutes were used to move unserviceable locomotives around in the shop area as needed. In 1947, S-8 class 0-6-0 No. 102, built by Baldwin in 1912, was selected to be rebuilt into the new "shop goat" and renumbered MW3230. The tender was removed and replaced by tanks over the boiler, so she could fit on the 110-foot turntable with large, unserviceable locomotives she might need to move. There is no headlight, since she was only used in the shop during the day. (Courtesy TRHM, Joe Thompson Collection.)

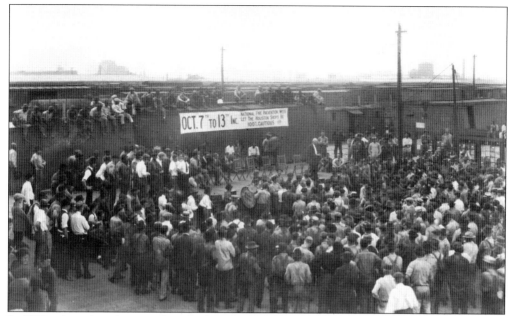

In 1928, when this photograph was taken, National Fire Prevention Week was only three years old, but after a major fire in 1920, Southern Pacific was obviously making it a big deal at the Hardy Street Shops. They have even brought out their Houston Shop Band for the occasion, and the presence of so many "suits" on the stage shows how seriously SP takes fire prevention. (Courtesy HMRC, HPL.)

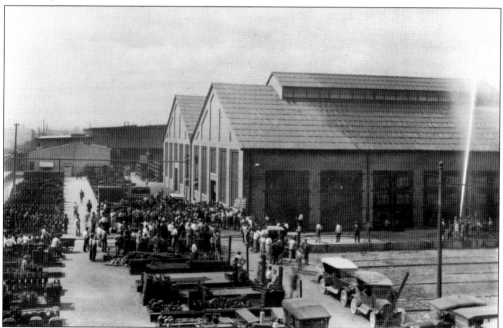

This view of Hardy Street Shops is looking east, with the Paint Shop in the foreground, the Upholsterer's Shop farther back on the left, and the Coach Repair Shop behind it on the right. The T&NO shops were originally located in this area, and when the GH&SA shops moved from Harrisburg in 1888, they were consolidated with them. (Courtesy HMRC, HPL.)

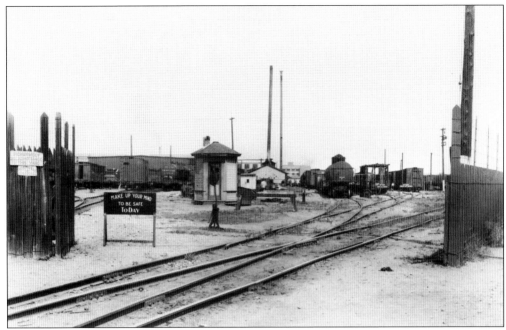

This might be called the "back door" to the Hardy Street facilities. This image is looking east from about where the North Main Underpass runs today. The large gray building on the left behind the guard's shack is the Car and Material Storage Shed. The SP shop facilities here were one of the largest industrial employers in the Southwest. (Courtesy HMRC, HPL.)

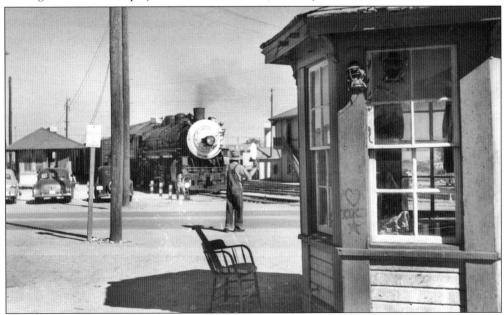

It is late in the afternoon of October 13, 1955, and the crossing tender is coming out of his shack at the approach of T&NO MK-5 class 2-8-2 No. 771, arriving at Hardy Street. Soon the Elysian Street Viaduct would cross over the SP's busy facility here, but for now, it was still the responsibility of the crossing tender to protect road traffic from approaching locomotives and trains. (Courtesy TRHM, Joe Thompson Collection.)

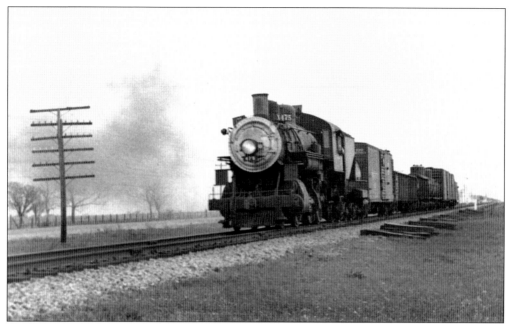

T&NO No. 475 leads a freight extra northwest of Houston. The little Mogul was built by Brooks in 1908 for the Cananea, Yaqui River, and Pacific Railway, a subsidiary of the SP in Mexico. The M-9 class 2-6-0 came to the H&TC in 1912 and was renumbered to become T&NO No. 475 in 1950. (Courtesy TRHM, Joe Thompson Collection.)

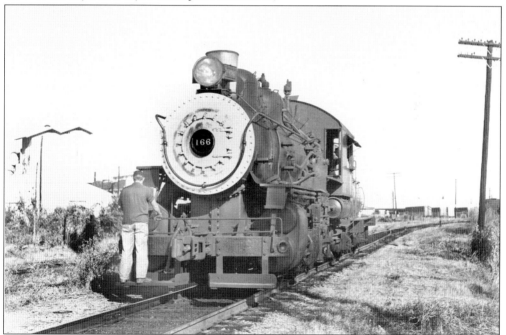

As a boy in 1943, Joe Thompson watched 0-6-0 Switcher No. 166 work the Bellaire subdivision of the SA&AP line west of Houston near his house. He loved to stop and talk to the train crew. When the SP acquired the SA&AP in 1925, it became an important second route to San Antonio and South Texas. It is now the Westpark Tollway. (Courtesy TRHM, Thompson Collection.)

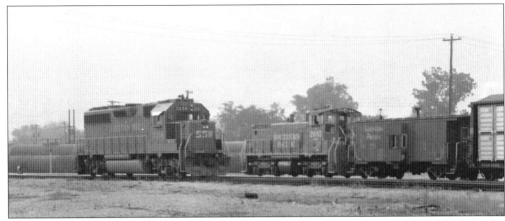

The little switcher here with the ubiquitous SP bay-window caboose is an SW1500 built by the Electro-Motive Division (EMD) of General Motors in 1973. Cotton Belt (St. Louis–Southwestern) GP40-2 No. 7258 was also an EMD model, and she first shows up on the SP locomotive roster in 1985. SP bought 240 of the little switchers and 168 of the road units. (Courtesy Tom Marsh.)

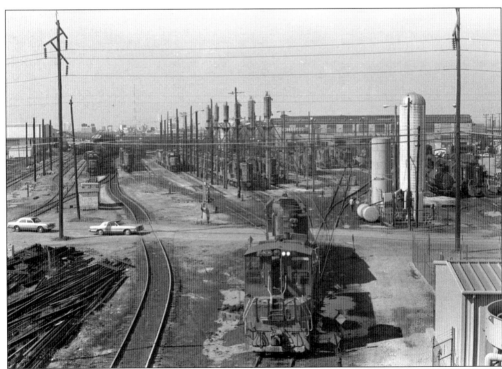

In this late-1970s photograph looking west into Hardy Street, sanding towers and fueling racks have replaced the huge roundhouse and turntable that once stood here. The massive black iron horses, breathing and hissing steam, have been replaced by rumbling, interchangeable, functional diesels, painted gray and scarlet. (Courtesy Tom Marsh.)

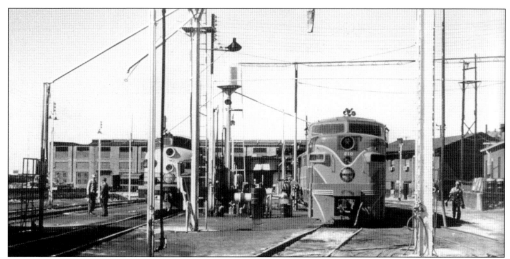

Steam is almost gone, but SP's Hardy Street Shops were still busy in November 1956, when George Werner exposed this image of F7-A No. 380 and ALCO PA No. 210 at the sanding towers, getting ready for their next assignments. The ALCO PA is wearing SP's beautiful "Daylight" paint scheme, also used on the Houston–Dallas streamliner *Sunbeam*. (Courtesy George C. Werner.)

For over a century, cabooses provided the "punctuation mark on the end of the train." This "crummy," SP No. 1659, following its train west on the old SA&AP line through Bellaire Junction under the West Loop, was built about 1963. These steel bay-window cabooses served as the traveling office of the train crew and provided such comforts of home as an icebox, oil-burning stove, and toilet. (Courtesy Tom Marsh.)

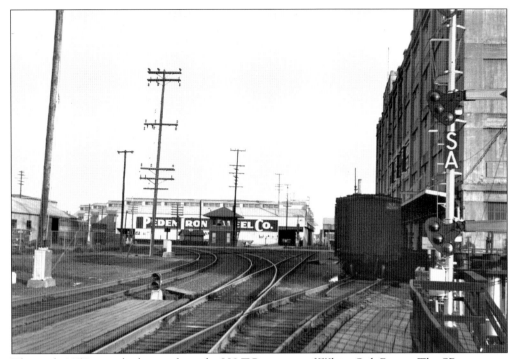

This early-1950s view looks east from the H&TC crossing of White Oak Bayou. The SP passenger main line curves off to the northeast toward where it met the T&NO main line to Englewood. Tower 108 controlled the junction of the SP and the Katy main lines and can be seen in front of the Peden Iron and Steel Building. (Courtesy TRHM, Joe Thompson Collection.)

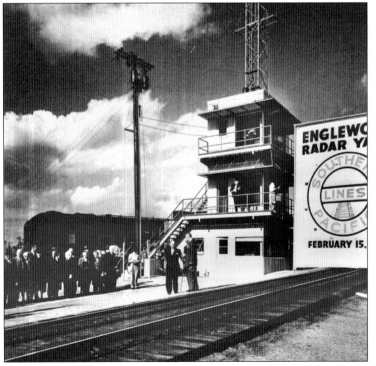

When "the hump" at Englewood Yard opened, it was widely recognized as one of the most modern gravity yards in the world. This is the control tower, located at the top of the hump. It housed the scalemaster and automatic scale equipment on the first floor, "automatic switching push-button panel board" on the second floor, and the yardmaster on the third floor. (Courtesy HMRC, HPL.)

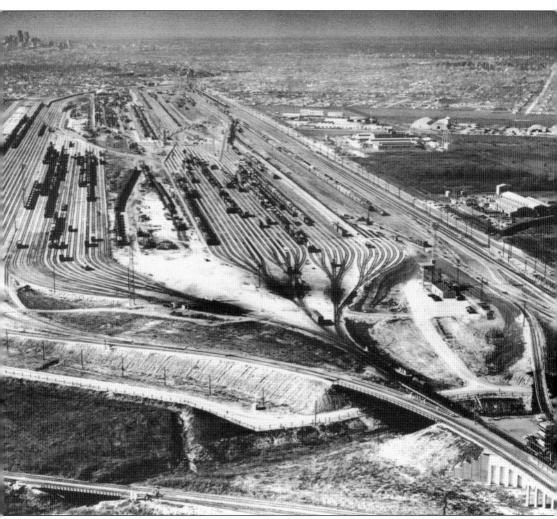

Englewood Yard was first developed by the SP on the T&NO main line on the east side of Houston in 1895, and became their major classification yard in 1915. In 1953, they began modernizing it into what the *New York Times* called "one of the biggest and most modern gravity switching yards in the nation," spending $6 million to expand the yard and add a "hump" and remote control switches and "retarders" to automatically control and slow the movement of cars down into the bowl of the yard to make up trains. Even though the movement of the cars is slow and well controlled, some cars carrying hazardous or fragile cargo should not be handled this way, and they are stenciled "Do Not Hump." This aerial view of Englewood looks west. The control tower at the top of the hump can be seen in the bottom right, and the Houston skyline is visible in the background. (Courtesy HMRC, HPL.)

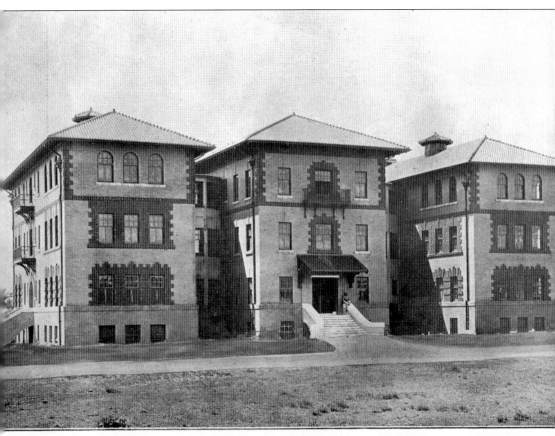

SUNSET HOSPITAL, HOUSTON, TEXAS

DEPARTMENT OF BUILDINGS AND BRIDGES OF THE G. H. & S. A. RY. Architects THE FRED A. JONES BUILDING CO., General G
 Otis Elevators Trinity Cement Agee Screens Lighted by Houston Light & Power Co. Mill Work by Houston Co-Operative Manufacturing C
 Reinforcing, Kahn System Waterproofing and Denton and Millsap Brick by F. B. Walcott

The oldest railroad hospital in the Southwest started in Columbus in 1880 as the Galveston, Harrisburg, and San Antonio Railway's hospital. It all began when Thomas W. Peirce, president of the GH&SA, contracted with Dr. Robert H. Harrison to treat all employees of his railroad at the new hospital for free. The railroad paid the hospital a monthly fee, and every employee had a small amount deducted from his pay to cover part of the cost. The hospital was moved to Houston in 1902. In 1904, the name was changed to the Hospital Association of the Sunset-Central Lines. This imposing structure was built in 1911 on Thomas Street in the Fifth Ward. The building is now Harris County Hospital District's Thomas Street Health Center. (Courtesy Texas Room, HMRC, HPL.)

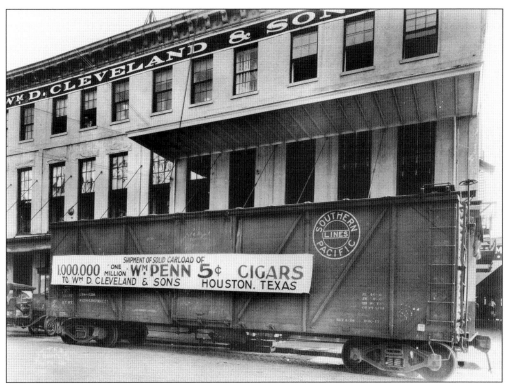

If Vice President Thomas Marshall thought the country needed a good 5¢ cigar, William D. Cleveland and Sons, one of Houston's largest wholesale grocers in the Roaring Twenties, was going to provide all his city needed. Here they are using a flashy advertising ploy parking a modern, 40-foot Southern Pacific boxcar loaded with $50,000 worth of cigars at their warehouse, decorated with a banner. (Courtesy HMRC, HPL.)

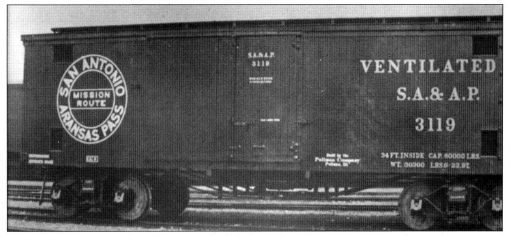

Ventilated boxcars, such as this one, which belonged to the SA&AP, were the predecessor and alternative to refrigerator cars in this part of Texas at least through the mid-1950s. They were used to haul farm products, such as watermelons, melons, and fruits that would have been grown in South Texas and the Rio Grande Valley, which the SA&AP served. Note the "Mission Route" medallion, which mimics the SP's "Sunset Route" medallion. (Courtesy Texas Collection, Baylor University.)

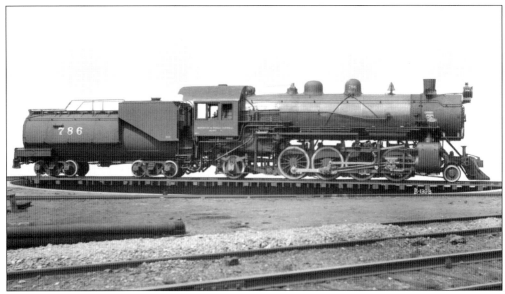

MK-5 class No. 786 was built by Brooks Locomotive Works in 1916 for the H&TC, with 63-inch drivers and 26-by-28-inch cylinders. It weighed 280,000 pounds and operated on 200 pounds' boiler pressure. In 1956, the T&NO decided to donate a steam engine to each division point city in Texas. Austin received the 786, and in 1989, she was leased by the Austin Steam Train Association and restored to working order. (Courtesy Texas Collection, Baylor University.)

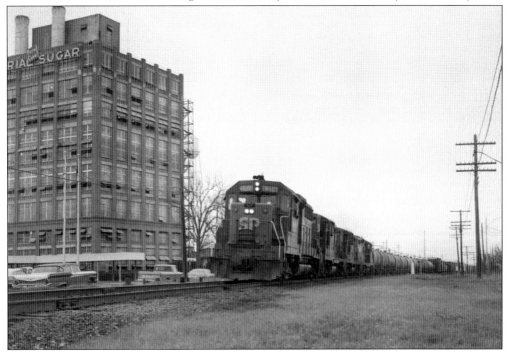

The location of sugar cane from large plantations in the area was one of the principal reasons for building the first railroad in Texas. Pictured 120 years later, a westbound SP manifest freight, led by GP-35 No. 6627, is passing the Imperial Sugar Company plant on the Sunset main line in Sugar Land just west of Stafford, where the BBB&C first ran in 1853. (Courtesy Tom Marsh.)

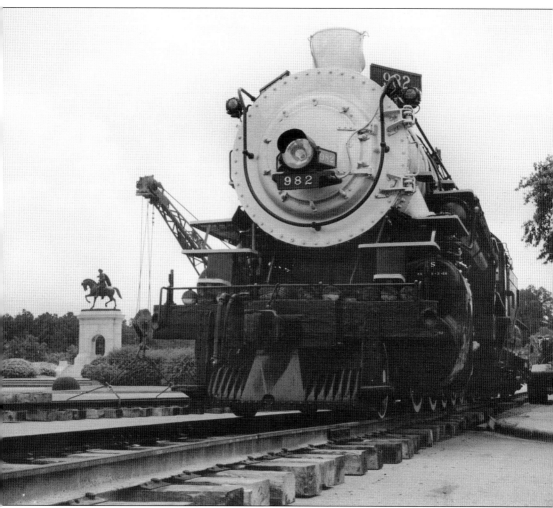

In the mid-1950s, as the T&NO completed its transition from steam to diesel, it donated eight locomotives to division headquarters cities. Houston received F-1 class 2-10-2 No. 982, built by Baldwin in 1919. After she had logged more than 3.5 million miles, the mile-and-a-half journey from the closest rail line to her new home in Hermann Park would take three days. The 188-ton, 92-foot-long engine and tender would be carefully towed over sections of special track; one piece of track would be picked up as the engine moved slowly down the road, tender first, and then placed back down on the other end for the tender to roll onto. In this photograph, she is almost there, inching toward the statue of Sam Houston, who seems to be urging her on. After almost 50 years, she was moved again to a special plaza across from Minute Maid Park, in downtown Houston. (Author's collection.)

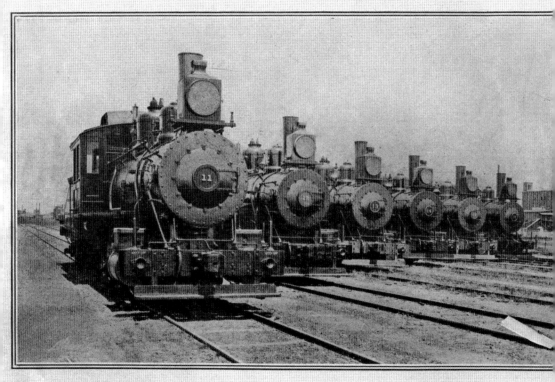

G. H. & H. Switch Engines on Galveston Terminal, Always Ready for Business.

Galveston was proud of its "Old Reliable Short Line." The Galveston, Houston, and Henderson Railroad operated under its own charter longer than any other railroad in Texas. This photograph is from a promotional brochure published by the *Galveston Tribune* in 1916, bragging that the "big 6" 0-6-0 switch engines of the GH&H were always "ready for business." With the shortest rail route to Galveston, the GH&H was leased or jointly owned over time by the Katy, the I&GN, and the Missouri Pacific, yet continued to operate its own terminal facilities until being merged into the MP along with the Katy in 1989. (Courtesy Texas Room, HMRC, HPL.)

Three

OTHER MAJOR LINES

The first railroad in Texas, the Buffalo Bayou, Brazos, and Colorado, would become the oldest part of the Southern Pacific Lines, but ironically the little "tap" line that Houston built to connect with it never did.

The Houston Tap and Brazoria became part of the International and Great Northern Railroad in 1873. The I&GN came under Jay Gould's control in 1882 and was operated in conjunction with the Missouri Pacific, which he also controlled. Houston's third railroad, the Galveston, Houston, and Henderson, was chartered in 1853 and came to be known as the "Old Reliable Short Line." It would continue to operate under the original charter for 136 years, longer than any other Texas railroad.

After the Gould interests lost control of the MP in 1917 and the I&GN in 1922, the MP began consolidating its own system in Texas. In 1925, they bought the New Orleans, Texas, and Mexico Railway (NOT&M), which had picked up the I&GN the year before. The NOT&M also controlled the "Gulf Coast Lines," including the Beaumont, Sour Lake, and Western and the St. Louis, Brownsville, and Mexico, giving MP control of a rail route to New Orleans and all the way to Brownsville.

The Burlington Route and the Rock Island Lines both reached Houston through their control of the Trinity and Brazos Valley Railway (T&BV) in the early 20th century. In 1905, the Colorado and Southern Railroad bought the T&BV, selling half interest in it to the Rock Island the next year. By 1907, through a combination of new construction and acquired trackage rights, the T&BV had reached Houston and gained access to Dallas, Fort Worth, and Galveston. The Burlington having bought out the C&S in 1930, the T&BV became the Burlington–Rock Island Railroad Company.

The Santa Fe began as Galveston's attempt to bypass Houston altogether with the Gulf, Colorado, and Santa Fe Railroad, chartered in 1873 to connect with the Denver and Rio Grande. In 1885, however, a branch was built from Alvin into Houston from the south.

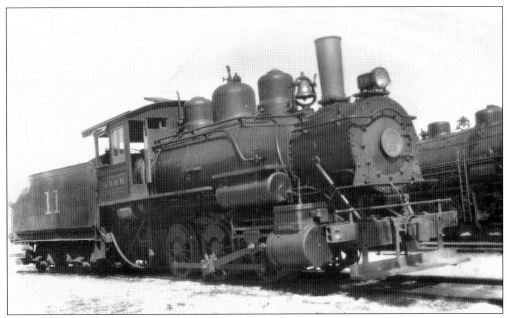

The GH&H must have been very proud of their little "Big 6" switchers because here we see No. 11, almost a quarter of a century later, still looking like new. She's still shiny, there's not a spot of rust on her, and one can still see "Richmond" on the steam chest, just above the cylinder, identifying her builder as Richmond Locomotive Works. (Courtesy TRHM.)

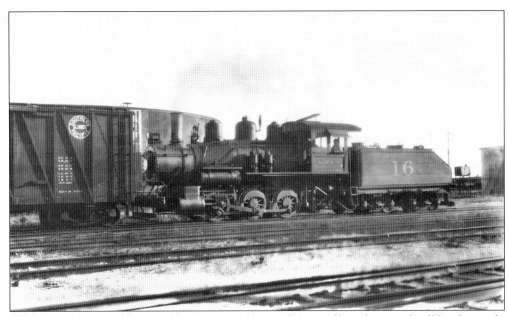

GH&H switcher No. 11's sister, No. 16, is seen here, still in excellent shape and still hard at work, putting together trains, probably in Galveston, in August 1934. These little switchers carried two sand domes, to direct sand in front of and behind the drivers for traction. (Courtesy TRHM.)

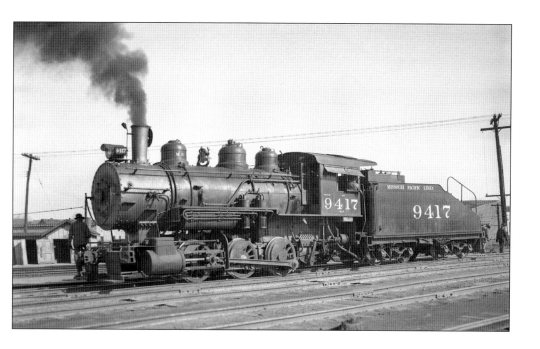

The 0-6-0 above, No. 9417, built by Baldwin for Missouri Pacific about 1907, is bigger than her GH&H sisters, weighing 151,000 pounds and developing 180 pounds of boiler pressure. Photographed February 15, 1935, in the Congress Avenue Yard, she had 20-by-26-inch cylinders and her six drivers could deliver 31,200 pounds of tractive effort. Seen below on the same day, MP 0-8-0 No. 9609 weighed 224,000 pounds and operated on 198 pounds' boiler pressure. With 25-by-28-inch cylinders powering 52-inch drivers, these massive switch engines didn't move very fast but could deliver 57,750 pounds of tractive effort. (Both photographs by William Monypenny, courtesy George C. Werner Collection.)

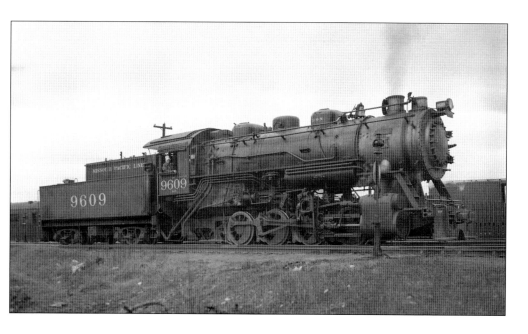

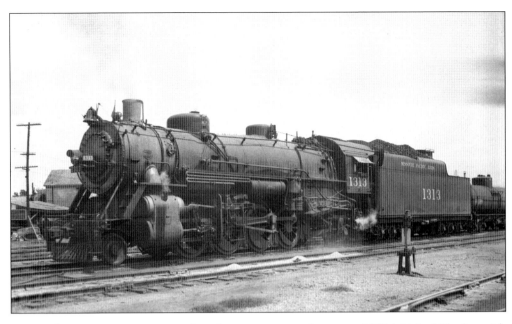

Despite their massive appearance, these locomotives were known as USRA Light Mikados, with a 2-8-2 wheel arrangement, and both belonged to Missouri Pacific's MK-63 classification. The 1313 in the above photograph is actually a little older than her sister, the 1120, having been built in 1919 by Lima Locomotive Works for the Missouri Pacific. She is also pretty unusual in Houston in that she burns lignite, or brown coal, which was a very low-grade energy producer. This photograph was taken in August 1934, at the Congress Avenue Yard, just east of downtown Houston. The No. 1120, being tended to at the Milby Street engine facilities nearby, was built by ALCO-Brooks in 1926, for the St. Louis, Brownsville, and Mexico. She burns fuel oil. (Both photographs by William Monypenny, courtesy George C. Werner Collection.)

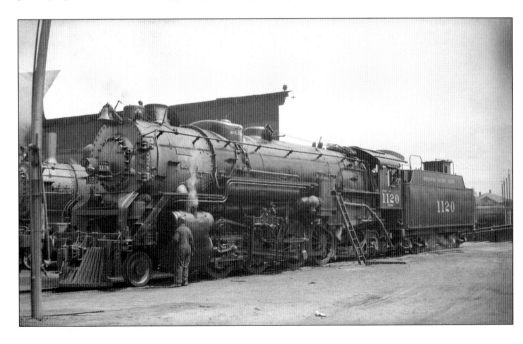

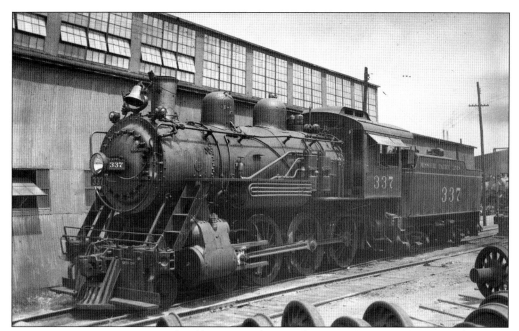

I–GN 4-6-0 No. 337 is up in age, but like any true beauty, she retains her classic lines and allure. She was built by Baldwin in 1911 with 20-by-28-inch cylinders and 63-inch drivers. The clerestory vent in her cab roof suggests an earlier, more graceful time. She was photographed in 1934 at the Milby Street shops. (Photograph by William Monypenny, courtesy George C. Werner Collection.)

Steel wheels on steel rails don't always give good traction. Therefore, steam locomotives carried dry sand that the engineer could drop onto the slippery rails to give them a little grip. On New Year's Day 1954, the roundhouse crew checks the sand in the sand dome of I&GN (MP) Pacific No. 1160 at the Milby Street roundhouse. (Photograph by Charles H. Kiefner, courtesy George C. Werner Collection.)

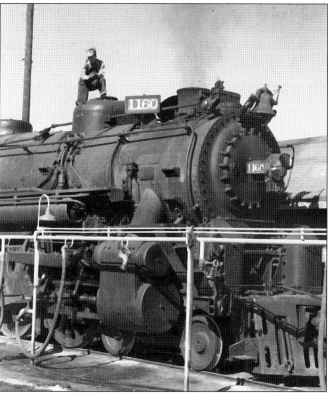

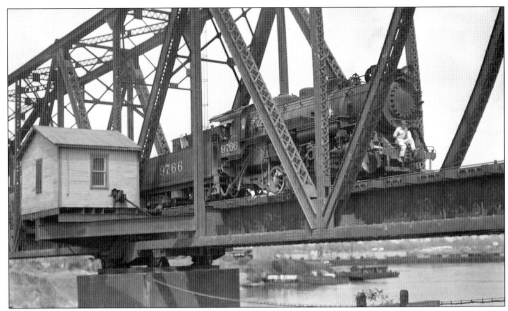

St. Louis, Brownsville, and Mexico's (MP) 0-8-0 No. 9766 is shown here crossing a swing-type bridge just above the Port of Houston Turning Basin on a hot August afternoon in 1953. After the turning basin opened in 1914, there was still a lot of bayou traffic, so all 10 railroad and highway bridges between here and downtown were either drawbridges or swing type. (Photograph by Charles H. Kiefner, courtesy George C. Werner Collection.)

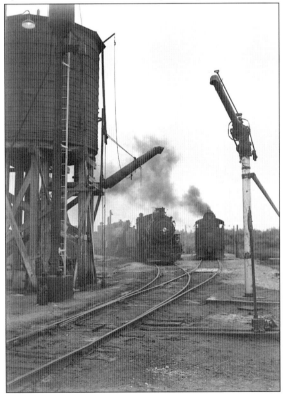

These three Missouri Pacific Lines (MP) locomotives were photographed on an early May 1950 morning in Freeport, Texas, waiting for access to the lifeblood of steam engines, water and fuel, which in Texas usually meant oil. Across the track from the water tower is the column that pumped fuel oil, usually from underground storage tanks. Their tenders held 10,000 to 12,000 gallons of water and 3,000 to 3,500 gallons of oil. (Photograph by Charles H. Kiefner, courtesy George C. Werner Collection.)

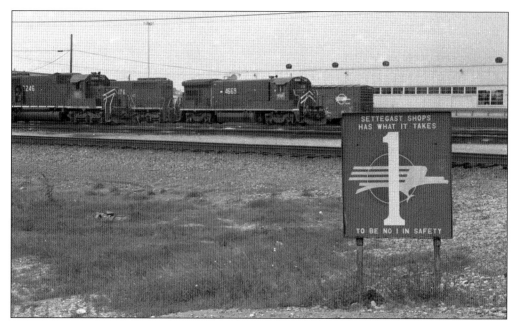

In 1950, Settegast Yard, on the northeast side of Houston, became the MP's primary freight classification yard in Houston, meaning it was where freight trains were broken down and made up. As the sign emphasizes, railroads were constantly pushing safety. Seen here are No. 3246 SD40-2, built by EMD in 1973, and No. 4669, a B23-7 built by GE in 1978, in dark Jenks blue with a small eagle on the cab. (Courtesy Tom Marsh.)

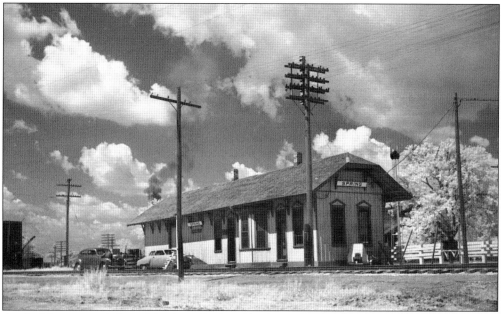

As the Houston and Great Northern Railroad built north toward Palestine, it reached Spring, Texas, in 1871, and a prosperous farming community grew up around the depot. The junction town boomed until the MP moved its engine facilities to Houston in 1923. Puffabelly's Old Depot Restaurant now occupies the site of the depot in Old Town Spring. (Photograph by Charles H. Kiefner, courtesy George C. Werner Collection.)

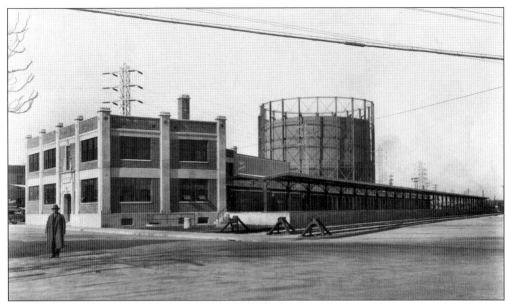

When the Missouri, Kansas, and Texas Railroad, better known as the Katy, arrived in Houston in 1893, they built their passenger and freight facilities and a small engine terminal just north of Buffalo Bayou and near White Oak Bayou. The brand-new freight warehouse and loading docks shown here were located on North Main Street, just north of the Katy passenger depot. (Both courtesy Charles Fennen.)

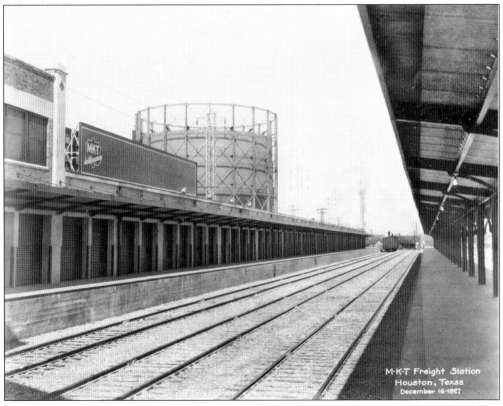

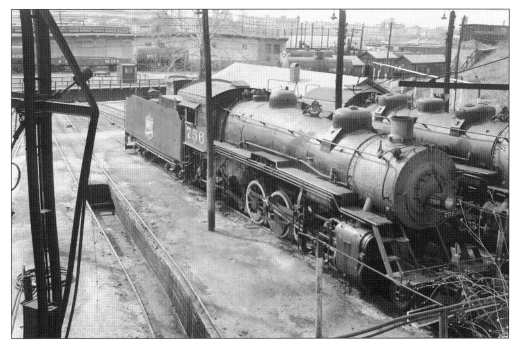

The Katy roundhouse was just a little west of its freight depot, within a stone's throw of the huge SP Hardy Street facilities. Houston's temperate climate allowed it to be simply an open turntable, with fan tracks around it but no enclosure. The photographer recorded this image on an afternoon in January 1952. No. 756 was a 2-8-2 class L-1-a Mikado. (Photograph by Charles H. Kiefner, courtesy George C. Werner Collection.)

In December 1950, Kiefner caught this shot of a Katy freight headed into Houston along Katy Road. Judging by the plume of smoke, No. 757 was making good time. These Mikes (Mikados) were among the heaviest freight equipment MKT needed over the gentle southeast Texas terrain. (Photograph by Charles H. Kiefner, courtesy George C. Werner Collection.)

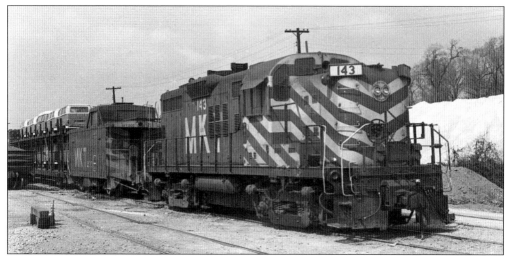

Tom Marsh captured this view of Katy No. 143 putting together a train at the Katy's Eureka Yard, where the MKT crossed the H&TC in west Houston. No. 143 was an RS3, RS meaning "road switcher," built by ALCO in 1951 and then rebuilt by EMD in 1959 because of problems with the original diesel motors. When Union Pacific bought the MKT in 1988, she would go to work for the South East Kansas Railroad. (Courtesy Tom Marsh.)

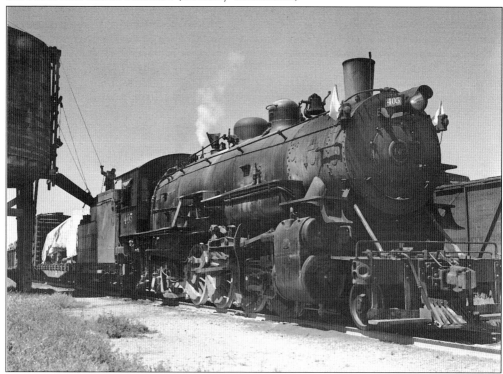

The Fort Worth and Denver Railway (FW&D) was Burlington's route from Fort Worth to Houston. Class E-4A1 2-8-2 No. 405 is taking on water at Tomball in April 1952. Mikados were the largest engines operated by the FW&D, although No. 405, built by Baldwin in 1915 and weighing in at 272,000 pounds, was not one of the heaviest. (Photograph by Charles H. Kiefner, courtesy George C. Werner Collection.)

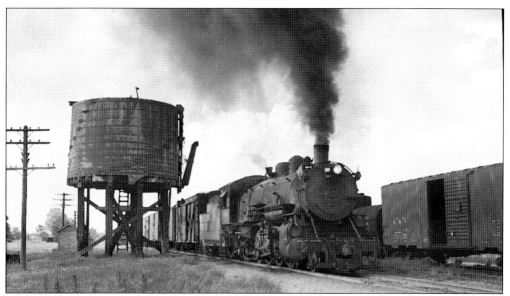

Mikado No. 405 must have been a regular on this run because here we see her again, going by the same ancient water tower at Tomball just a few days later. The white flags on the front of the engine indicate that this train is being run as an "extra." In the lower photograph, the Tomball station agent is handing up train orders, on the end of the long stick in her hand, to the fireman standing in the gangway, with the engineer in his place at the throttle. Women first began temporarily filling such jobs as clerks and station agents during World War I, and after World War II, women stayed on in many such jobs, especially in rural areas. (Both photographs by Charles H. Kiefner, courtesy George C. Werner Collection.)

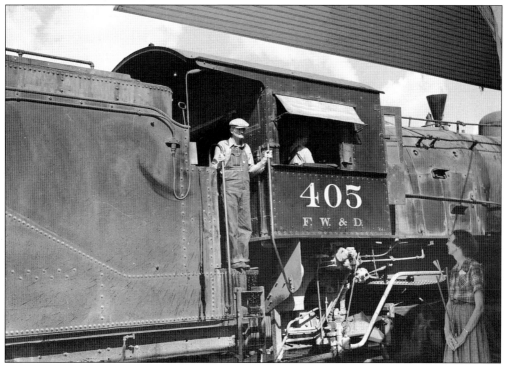

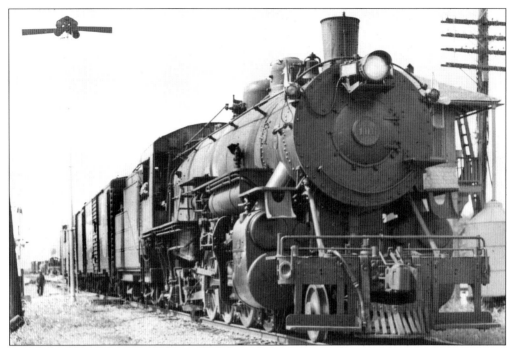

FW&D E4A1 class Mikado No. 406 was No. 405's younger sister, having been built by Baldwin in June, just a month after No. 405. She would have a few more years, though; No. 405 would meet the torch in October 1956, while No. 406 would have until March 1960. (Courtesy TRHM.)

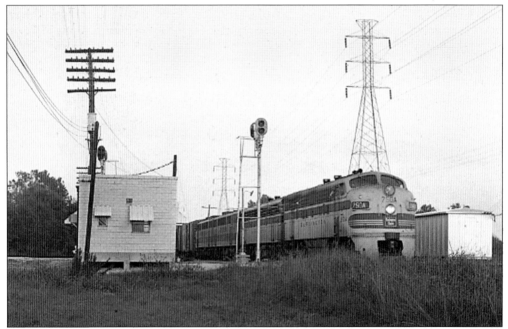

George Werner captured FW&D (Burlington) F-9 No. 750A on the point of an ABBA lash-up of F-units on October 11, 1964. Train No. 76 is at Belt Junction, where the HB&T crossed the I–GN (MP) line just north of where the Hardy Toll Road meets Loop 610. (Courtesy George C. Werner Collection.)

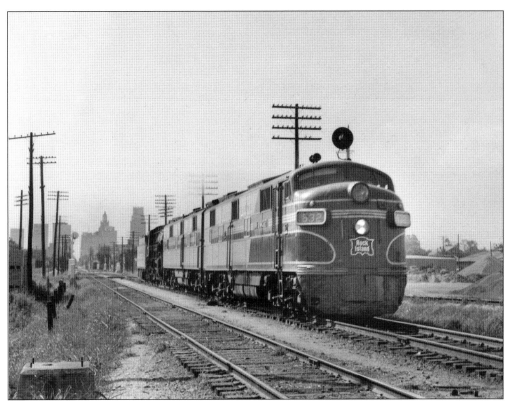

A Rock Island E7A-B-A set and what appears to be a Santa Fe Pacific lope back to the Milby Street roundhouse from Union Station after a hard day of delivering their charges to Houston. E7A No. 632 was built in 1948 by the General Motors Electro Motive Division. (Courtesy TRHM.)

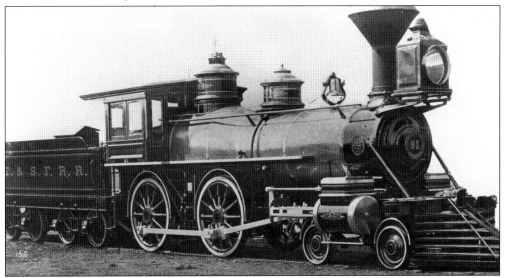

Looking both beautiful and business-like, and representative of the early locomotives that would have run on the Gulf, Colorado, and Santa Fe, is the Atchison, Topeka, and Santa Fe No. 91. She was built by Baldwin in 1879, weighed 71,000 pounds, had 17-by-24-inch cylinders and 57-inch drivers, and operated on 130 pounds' boiler pressure. (Courtesy TRHM.)

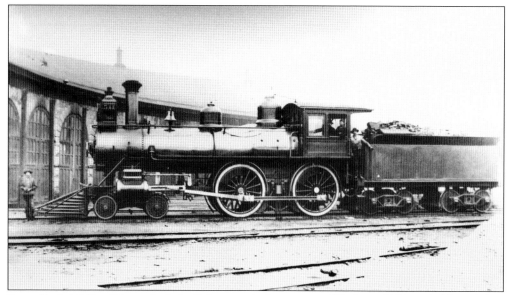

Santa Fe 4-4-0 No. 511 was built by Schenectady Locomotive Works in 1887, and although less than 10 years newer than No. 91, she demonstrates how steam locomotives were steadily growing larger and heavier. She weighed 99,500 pounds, had 18-by-24-inch cylinders driving 69-inch drivers, and operated on 150 pounds' boiler pressure. (Courtesy TRHM.)

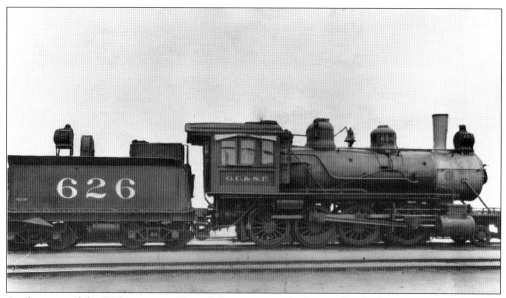

At the start of the 20th century, Consolidations were the heavy freight locomotives. While not as heavy or powerful as the behemoths to come later, they were prettier. GC&SF 2-8-0 No. 626 was built by the Richmond Locomotive Works in 1894 and burned coal. She had 20-by-26-inch cylinders and 57-inch drivers, operated on 180 pounds' boiler pressure, and weighed only 129,000 pounds. (Courtesy TRHM.)

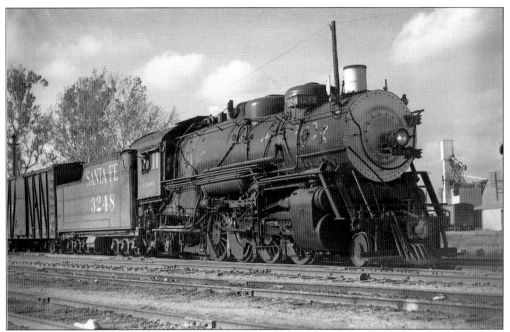

The Santa Fe was another Lone Star line that made good use of Mikados around Houston. No. 3248, on the point of Extra West near Alvin in April 1951, was built by Baldwin in 1919, with 27-by-32-inch cylinders and 63-inch drivers. She was built as a coal burner but converted to burn oil. (Photograph by Charles H. Kiefner, courtesy George C. Werner Collection.)

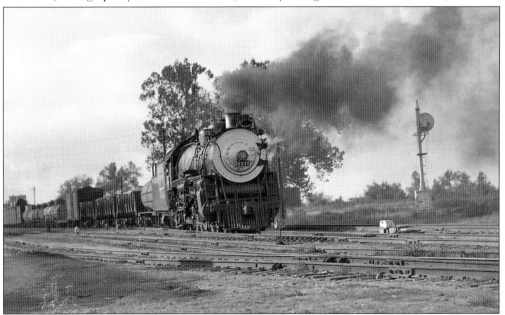

A Mountain-type locomotive, Santa Fe 4-8-2 No. 3715 was built in 1920 by Baldwin Locomotive Works with 28-by-28-inch cylinders and 69-inch drivers and operated on 210 pounds of boiler pressure. Her tender carried 12,000 gallons of water and 4,031 of fuel oil. She is seen pulling a long mixed freight through Alvin in October 1951. (Photograph by Charles H. Kiefner, courtesy George C. Werner Collection.)

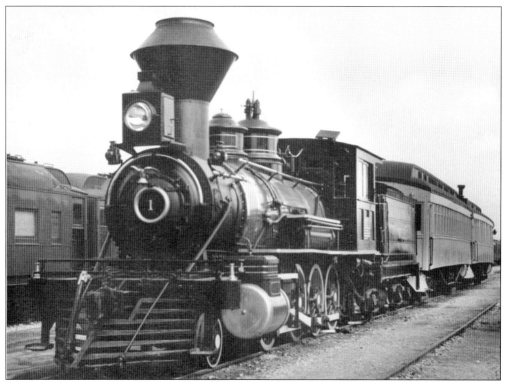

In 1941, Santa Fe rescued an old shop goat and restored her. She was christened No. 1, the *Cyrus K. Holliday*, named for a founder and first president of the road, and matched up with two restored 1880s wooden coaches. She was photographed at Union Station in 1957. (Courtesy TRHM.)

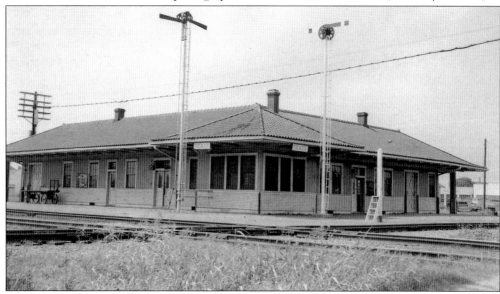

The Gulf, Colorado, and Santa Fe Railway established the town of Sealy, named for railroad president George Sealy, in 1875. This little station served as the Union Depot for the Santa Fe and the Katy, which crossed the Santa Fe here in 1892 with its line connecting Houston with San Antonio and Waco. (Courtesy TRHM.)

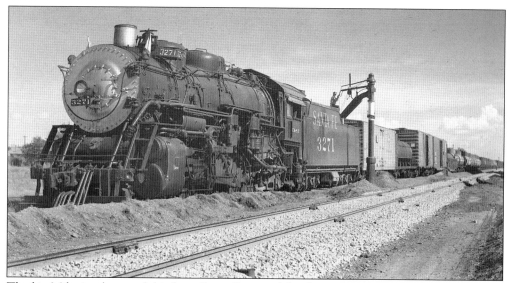

The big Mike in charge of this long Santa Fe mixed freight stopping to take on water at Sealy was built by Baldwin in 1920, had 63-inch drivers, and weighed almost 259,000 pounds. Anyone who has endured the hot August Texas sunshine can empathize with the fireman as he works to get the waterspout into the hole of the 12,000-gallon tank. (Photograph by Charles H. Kiefner, courtesy George C. Werner Collection.)

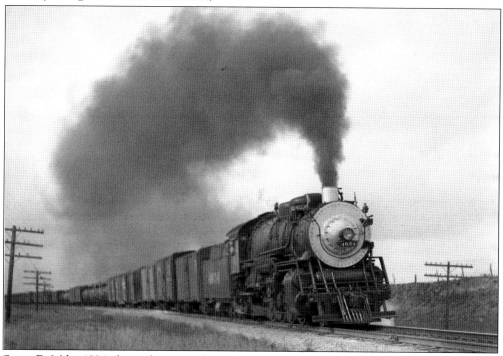

Santa Fe Mike 4034, shown here rounding the curve out of Sealy with a long mixed freight and the ubiquitous white flags of an "extra," was built by Baldwin in 1923, operated on 200 pounds' boiler pressure, drove 27-by-32-inch cylinders, and weighed 327,000 pounds. Photographed in April 1951, she had a little more than four years of service remaining. (Photograph by Charles H. Kiefner, courtesy George C. Werner Collection.)

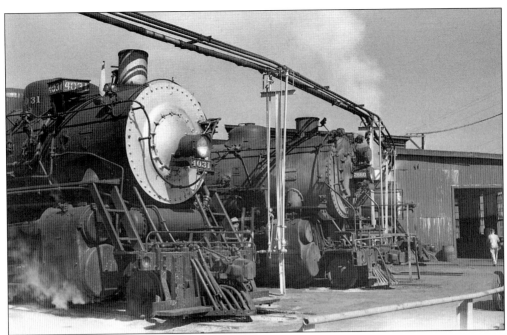

The white flags on this Santa Fe 4000 class 2-8-2 suggest she has just returned to Milby Street after hauling a freight train into Houston. Built by Baldwin in 1923, with 27-by-32-inch cylinders and 63-inch drivers, she was destined to be scrapped in August 1953. Resting next to her is Rock Island No. 2660. (Courtesy George C. Werner Collection photograph by Charles H. Kiefner.)

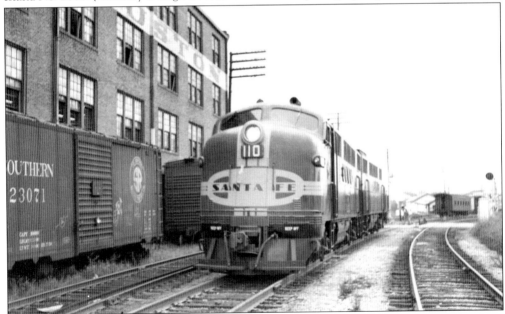

Pictured here are two of the machines that did in the big steam locomotives: Santa Fe FT-A No. 110, built by GM's Electro-Motive Division in May 1942, and probably FT-B No. 110A. The FTs were EMD's first diesel units built for freight service, developing 1,350 horsepower. Diesels needed less maintenance than steam engines, and although not as powerful singly, railroads would learn to use them effectively. (Courtesy TRHM.)

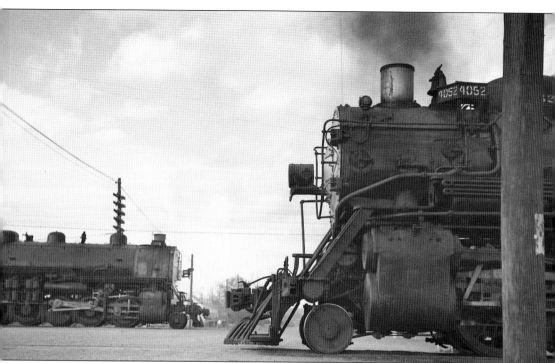

When the Gulf, Colorado, and Santa Fe Railroad, building northwest from Galveston in 1880, reached Richmond, their "request" for right-of-way through the town was refused. So the Santa Fe moved their line 3 miles to the west and established a new station where it crossed the Galveston, Harrisburg, and San Antonio Railway's main line, naming the town for Swiss immigrant Henry Rosenberg, second president of the GC&SF. Here we see an eastbound (southbound by timetable) Santa Fe freight pulled by 2-8-2 Mikado No. 4052, built by Baldwin in 1923 and weighing 246,000 pounds. Silhouetted behind it is a westbound freight pulled by T&NO 2-10-2 No. 906. (Photograph by Charles H. Kiefner, courtesy George C. Werner Collection.)

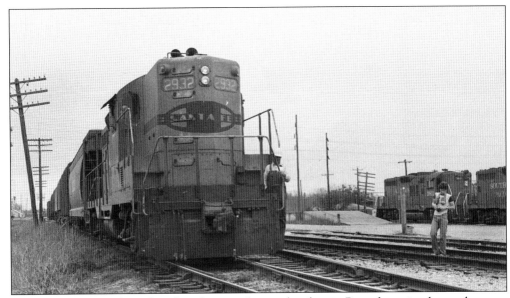

It is two generations later, but this photograph was also shot in Rosenberg, in almost the same location as the one on page 67; the Santa Fe and Southern Pacific are still very busy, and photographers are still taking pictures of freight trains. Here Tom Marsh has captured Santa Fe GP-7 No. 2932 in the lead with a freight train headed for Houston. (Courtesy Tom Marsh.)

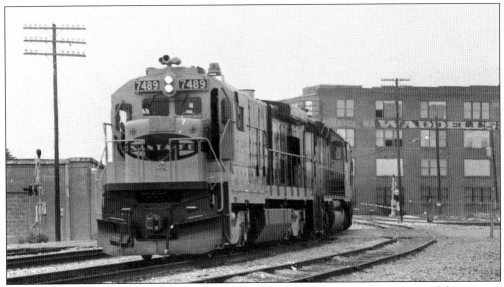

Santa Fe No. 7489 and another "Dash 7" are shown rounding a curve just east of downtown, approaching the Milby Street facility in the early 1980s. In 1980, Santa Fe purchased 16 of the 230 B36-7 diesels built by General Electric. (Courtesy Tom Marsh.)

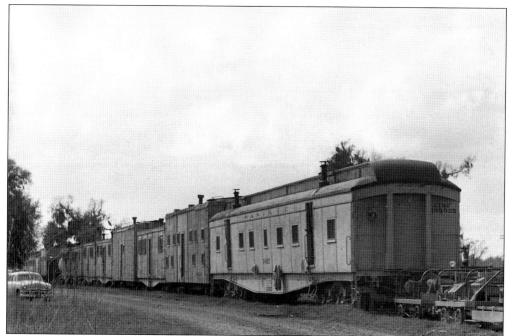

For the right-of-way and bridge crews, working on the railroad often meant weeks away from home, with no motels for miles. Instead the railroads provide bunk or dormitory cars, kitchen cars, and all the comforts of home, often in refurbished old passenger cars. This Santa Fe work train was at Thompsons, in Ford Bend County. (Photograph by Charles H. Kiefner, courtesy George C. Werner Collection.)

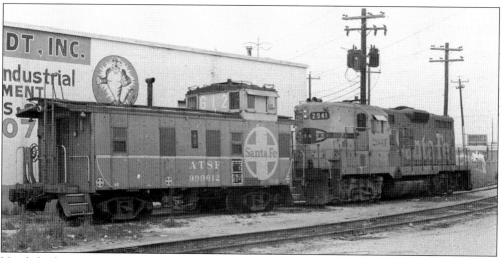

Until the late 1980s, cabooses served as bunkhouse, dining room, and office for the conductor and train crew and carried the markers, bringing up the rear on all trains. Santa Fe "Way Car" 999612 was a class Ce-3, built in 1949 and rebuilt and modernized in 1976. The Way Car and GP-7 No. 2914 are probably on their way from Milby Street, where the crew would have boarded, to pick up their train. (Courtesy Tom Marsh.)

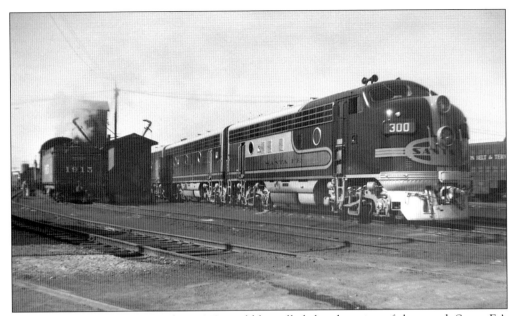

This scene, at Milby Street in late 1949, could be called the changing of the guard. Santa Fe's 1,500-horsepower F7 No. 300 is brand-new and the picture of the future. Consolidation No. 1915, drifting into the background on the left, was built by Baldwin in 1913. (Courtesy George C. Werner Collection.)

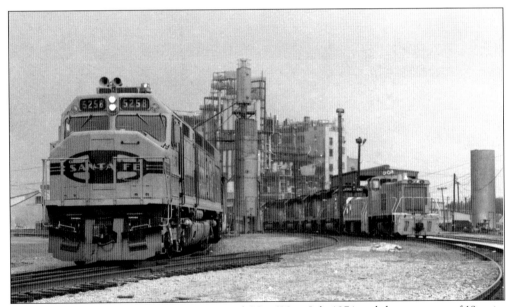

Santa Fe SDF40-2 began her career as Amtrak No. 628 in July 1974 and then was one of 18 units transferred to the Santa Fe and rebuilt for freight traffic in March 1985. Tom Marsh has photographed her in the traditional freight blue and yellow livery, with several Burlington Northern diesels and an HB&T switcher at the Milby Street fuel and sanding racks. (Courtesy Tom Marsh.)

Four

SHORT LINES, STREETCARS, AND INTERURBANS

Several of the 17 or 18 railroads that "met the sea" in Houston weren't very long, and a couple of them were actually belt lines that connected other railroads and provided terminal and switching services for them. Houston was also served by electric streetcars, like those of older, Eastern cities, and by two interurban electric railroads. And the city that now is just beginning to implement light rail once experimented with the idea of building a monorail.

The Houston Belt and Terminal Railway was formed in 1905 by B. F. Yoakum to provide both freight and passenger switching operations and terminals for his Gulf Coast Lines roads—the Trinity and Brazos Valley, the Beaumont, Sour Lake, and Western, and the St. Louis, Brownsville, and Mexico. The Gulf, Colorado, and Santa Fe was also brought in, each owning 25 percent. The Houston Belt and Magnolia Park was an earlier short line built to connect Houston and the Ship Channel in 1889. It was acquired by the I&GN, eventually giving the MP its first access directly to the port. In 1924, the Port Terminal Railroad Association was formed to provide equal access to the port for all Houston railroads, with track being built by the forerunner of the Port Authority.

When streetcars first appeared in Houston in 1868, they were not electric but mule-drawn. In 1891, they were electrified, and the next year, a line was opened all the way out to the Houston Heights, Houston's first suburb, made possible by the new light rail. They grew with the city until there were 24 routes and over 90 miles of track by the late 1920s, including lines to Harrisburg and Bellaire. In 1911, the Galveston-Houston Electric Railway opened, offering fast hourly interurban service from Houston's Union Station to Galveston. The interurban's elegant blue coaches, proclaiming "Speed with safety," would streak up and down their tangent for a quarter of a century. Houston's other electric interurban, the Houston North Shore Railway, opened in 1927, connecting downtown Houston with Baytown and the Humble Oil Refinery and providing needed transportation to rural east Harris County.

The founder of the Houston Belt and Terminal, Benjamin Franklin Yoakum, was born in Limestone County in 1859 and began his career in railroading as a chain bearer and rodman, surveying for the International and Great Northern Railroad. He worked for Jay Gould, promoting his railroad interests in Texas before returning to a colorful career in railroad management in 1886. After various rail jobs, he moved to the Santa Fe, then the St. Louis and San Francisco Railway, where he became general manager in 1897. Under his management, the Frisco grew from 1,200 to 6,000 miles. Yoakum had dreams of building a pan-American railroad and so was persuaded to develop the system known as the Gulf Coast Lines, including the Beaumont, Sour Lake, and Western and the St. Louis, Brownsville, and Mexico Railroads, to connect the Rio Grande Valley with New Orleans through Houston. He is remembered as one of the most influential railroad builders in Texas. (Courtesy, Texas Room, HMRC, HPL.)

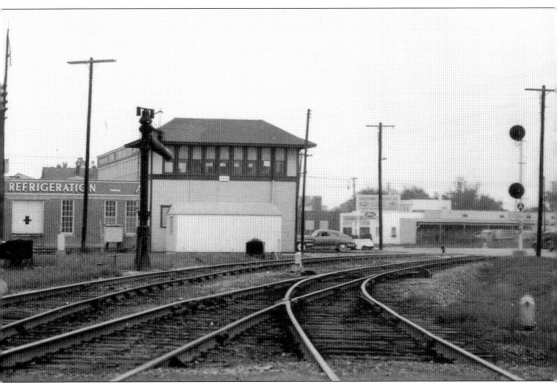

In the days before computers and electronic technology, railroad junctions were protected by "interlocking towers," such as this one, guarding the entrance to Union Station. From the second-story tower, operators could observe train movements and control the alignment of switches, guiding trains into their safe routing. In Texas, all interlocking towers were authorized by the railroad commission and given a specific number. This was Tower 116, and it controlled not only the approaches to both the passenger and freight stations, but also HB&T's crossing of the old GH&H line. Like many of Houston's historic sites, this is now the middle of a parking lot just east of U.S. 59. (Courtesy TRHM.)

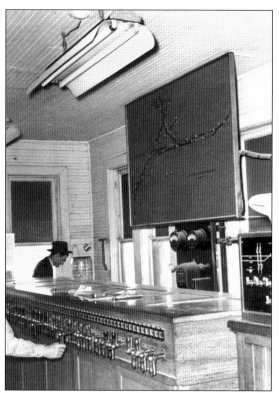

Here one sees the second-floor interior of Tower 116 around 1950. The large diagram on the board shows the track layout of the Union Station wye. Every dot on the schematic represents a switch or signal that is controlled by the knobs and levers visible on the cabinet underneath. The gentleman in the black fedora by the windows is Harold H. Vinson, tower man at Tower 117. (Courtesy TRHM.)

Vinson, whose home tower was near the University of Houston, is shown visiting Tower 84, where the San Antonio and Aransas Pass (SP) crossed the HB&T and the I&GN, just about a mile southeast of Union Station and Tower 116. The gentleman in the white shirt at the controls of Tower 84 is the tower man, Mr. Wiese. (Courtesy TRHM.)

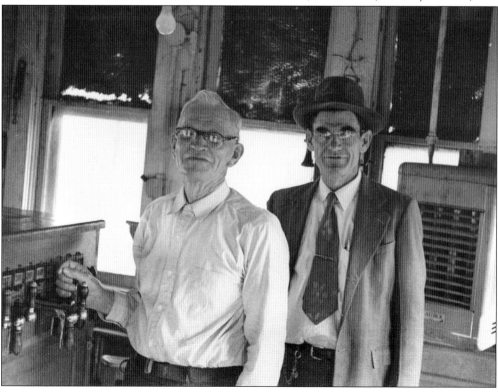

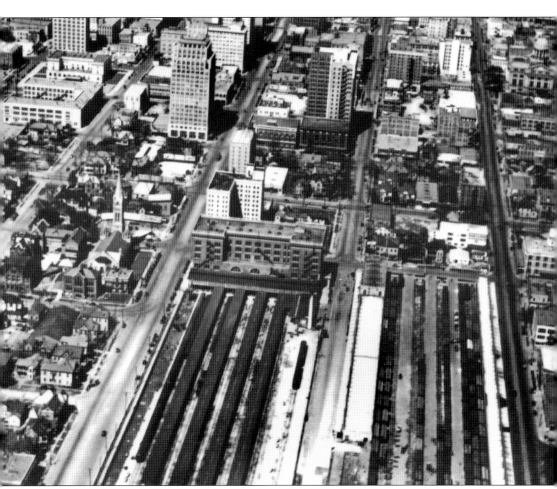

Houston Belt and Terminal Railway (also called the "Belt") not only operated Union Station for its owning railroads but also an extensive freight, Railway Express, and mail terminal facility. In this aerial view is Union Station in the center, at the corner of Crawford Street and Texas Avenue. All of this area, from Texas Avenue to a block beyond Preston Street, is now Minute Maid Park. To the right of Union Station is the HB&T freight depot. The long building with the light-colored roof is the inbound freight house and is now the middle of left field to the infield between first and second base on the baseball field. The long, narrower, light-roofed building on the other side is the outgoing freight house, about the present location of the right-field fence. (Courtesy HMRC, HPL.)

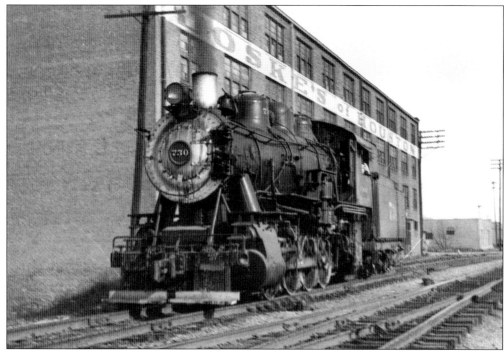

No. 730 began its career with the Santa Fe in 1900 as a 2-8-0, built by Baldwin to move heavy freight trains. No. 730 was given a new boiler and turned into an 0-8-0 at Santa Fe's shops in Cleburne in 1931. She is shown here working along Sampson Street in 1950. (Courtesy TRHM.)

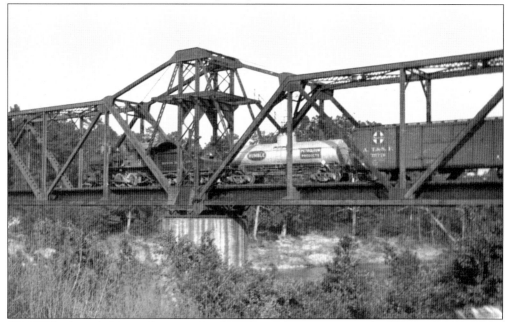

HB&T No. 3, an 0-6-0 switch engine, lumbers across the HB&T swing bridge over Buffalo Bayou just northeast of downtown. The wooded scene makes it hard to believe it is less than a mile from downtown. There was heavy barge traffic on the bayou, and the bridge is still required by the coast guard to open—"given 24 hours notice." (Photograph by Harry J. Heaney, courtesy TRHM.)

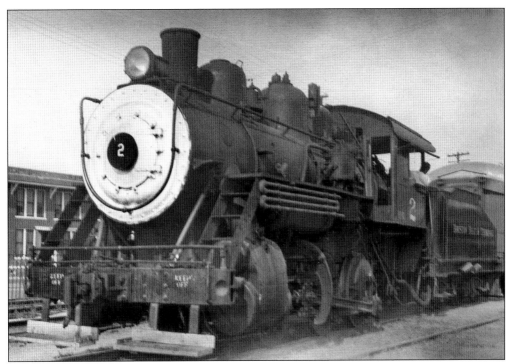

In addition to switching freight for its owning railroads, HB&T was also responsible for putting together the passenger trains that served Houston's Union Station. Here HB&T switcher No. 2 is seen shifting what appears to be a storage mail car. (Courtesy TRHM.)

HB&T No. 23, an EMD SW9 built in August 1951, is taking a spin on Milby Street's turntable in 1977. HB&T acquired its first diesel in 1940, and its little 0-6-0 steam switchers were replaced with a wide variety of diesel switchers, 20 S-2s and nine other SW9s, and several SW1200s and SW1500s. Milby Street's turntable is still there today. (Courtesy Phil Whitley.)

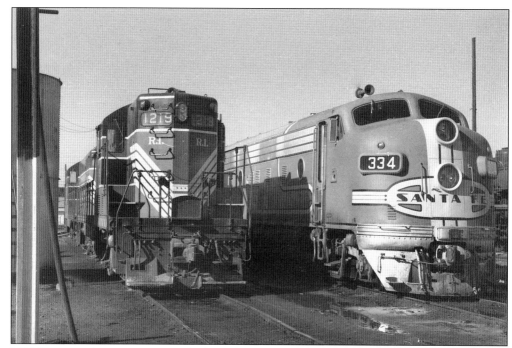

HB&T operated engine-servicing facilities for its owning railroads at Milby Street Roundhouse, about 2 miles from Union Station. Both the Rock Island, as part of the Burlington–Rock Island system in Texas, and the Santa Fe owned 25 percent each of HB&T. In January 1954, George Werner photographed (above) RI GP-7 No. 1219, built by EMD in late 1951, alongside Santa Fe EMD F-unit No. 334, built in June 1951. The Santa Fe No. 334 was geared for "dual purpose," to pull passenger or freight trains. About 24 years later (below), Tom Marsh photographed EMD GP38-2 No. 4325. Built in 1976, it was one of the last locomotives bought by RI and was named *Nebraska*. (Above courtesy George C. Werner Collection; below courtesy Tom Marsh.)

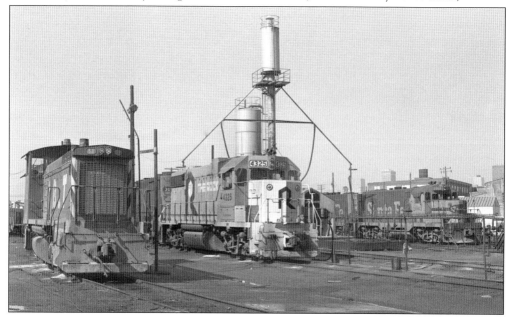

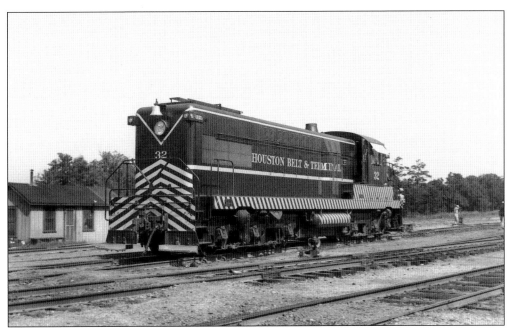

HB&T No. 32, photographed at New South Yard wearing HB&T's somber and businesslike basic black with white safety stripes, was the only Baldwin AS 616 the Belt owned. Built in 1952, she developed 1,600 horsepower and rode on six-wheel trucks, which gave the engine extra traction at low speeds. (Courtesy TRHM.)

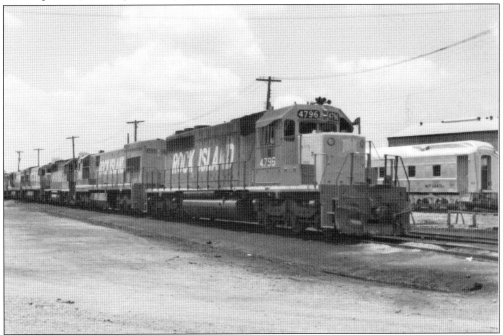

The Rock Island had a long line of diesels being serviced at Milby Street in 1977. First is No. 4796, a General Motors EMD SD 40-2 built in 1973. These were popular locomotives, dependable and economical, but the RI only purchased 10. No. 4599, a General Electric U30C, also was built in 1973 and developed 3,000 horsepower riding on six-wheel trucks. (Courtesy Phil Whitley.)

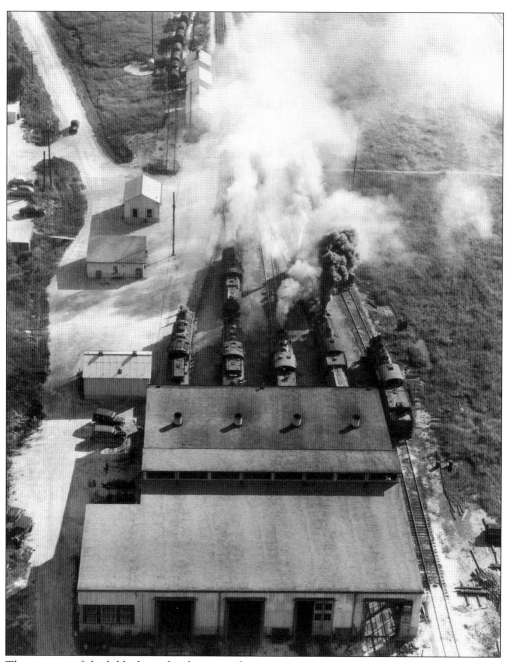

The amount of thick black smoke these iron horses are pouring out suggests their hostlers were aware they were being photographed. This is the engine terminal of the Port Terminal Railroad Association (PTRA), located in North Yard, just east of North Wayside Drive and north of the turning basin. Before the PTRA was established in 1924, only the Southern Pacific, International and Great Northern, and Houston Belt and Terminal actually operated tracks into the port. (Courtesy HMRC, HPL.)

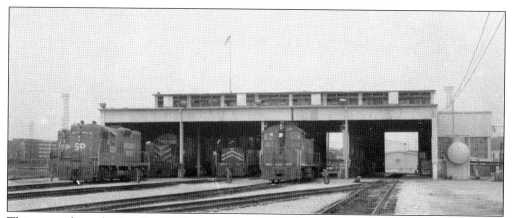

Thirty years later, the Port Terminal's engine house looks the same, except that diesels have replaced steam locomotives. PTRA still has to rely on power leased from its owning roads, though, which is why we see SP, Katy, and MP engines all rounded up together. (Courtesy Tom Marsh.)

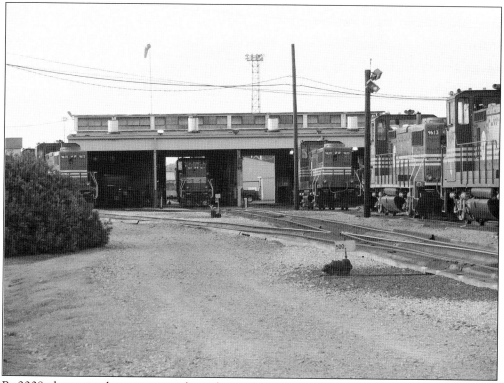

By 2008, the engine house was mostly unchanged, but the motive power all wears the same livery. In 1997, PTRA began leasing their own locomotives instead of relying on their member lines. These are dependable, smart-looking little workhorses, even if their colors are borrowed from the Dallas Cowboys. (Photograph by the author.)

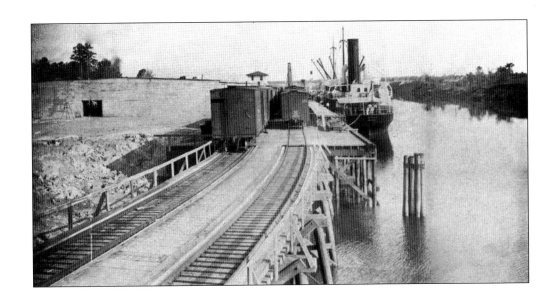

This is where Houston's railroads "met the sea" after the deepening of the Ship Channel and opening of the Port of Houston Turning Basin in 1915. These photographs, from the 1915 *Illustrated City Book of Houston*, show stevedores hard at work loading cotton and other cargo directly from railcars on rails that will become part of the PTRA in 10 years. The wharves and the municipal warehouse, on the left in the picture at the top, appear to be brand-new and still not completely finished. The SS *Satilla* was the first oceangoing steamship to arrive at the turning basin. (Both courtesy Texas Room, HMRC, HPL.)

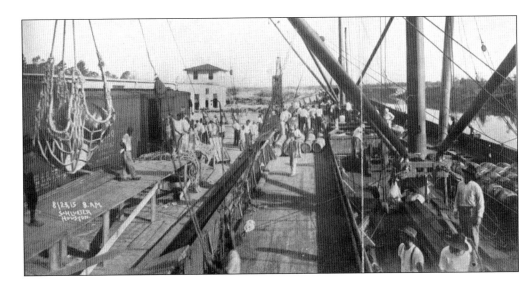

This photograph, made almost 50 years later and right across the channel from the previous two, shows that cargo was still being loaded directly from the railcars onto the ships. But evidence of change is visible on the ship's deck. Visible just above the gondola are two containers strapped to the deck, signaling the wave of the future. (Courtesy HMRC, HPL.)

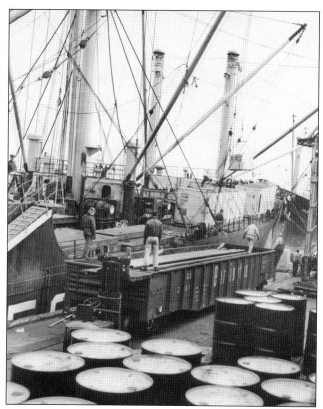

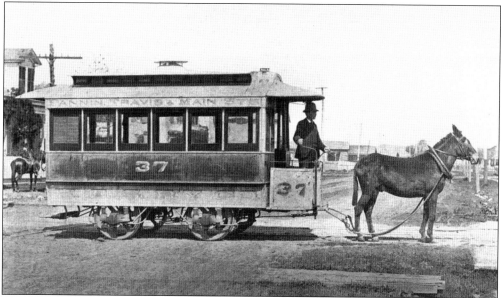

The Houston City Street Railway began a mule-drawn streetcar line on Travis Street in May 1874, gradually expanding its lines until it covered much of what is now the Central Business District. This handsome car, with its dapper driver and stoic mule, was photographed about 1885 at the corner of Preston and Dowling Streets, in what was then a residential area. (Courtesy Texas Room, HMRC, HPL.)

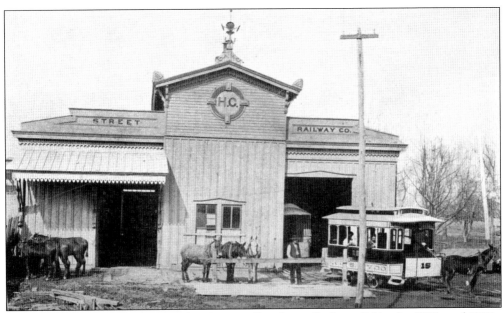

Operating a fleet of mule cars, as the Houston City Street Railway did in the 1870s and 1880s, required a lot of mule power. In 1890, the street railway owned 120 mules and 40 cars and carried one and a half million passengers! This beautiful little clapboard-frame structure was one of the barns where the mules were stabled and the little cars were stored and maintained. (Courtesy Texas Room, HMRC, HPL.)

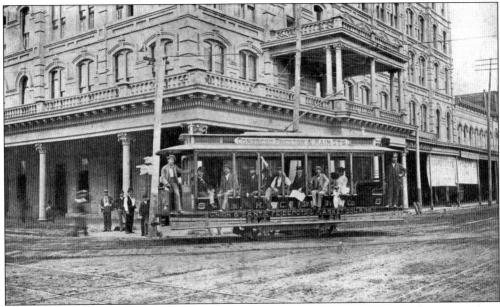

One of the first electric streetcars in Houston was photographed rounding the corner from Main Street on to Texas Avenue in front of the Capitol Hotel in late 1891. The gentleman on the second seat, wearing a suit and white shirt, was H. F. MacGregor, president of Houston City Street Railway, a founder of the Houston Symphony, and the man for whom MacGregor Park is named. (Courtesy Texas Room, HMRC, HPL.)

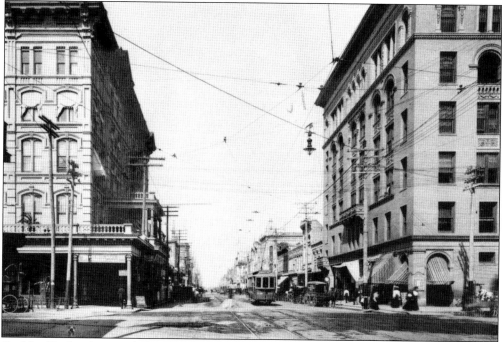

Car No. 12 is heading south down Main Street toward Texas Avenue. This intersection, illuminated by a modern arc light, was the heart of Houston at the dawn of the 20th century. The Rice Hotel (left) had just been renamed to honor the murdered William Marsh Rice, and the six-story Binz Building, Houston's first "skyscraper," was right across the street. (Courtesy HMRC, HPL.)

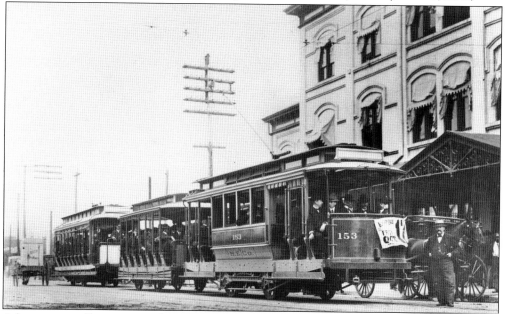

A large group of businessmen from Ohio has just arrived at Houston's Grand Central Station in October 1902, and it would appear some special cars have been chartered by the Houston Electric Company to provide transportation. In the lead is a brand-new "California Car," No. 153, pulling trailer No. 33, followed by a nine-bench open car dating from 1896. (Courtesy HMRC, HPL.)

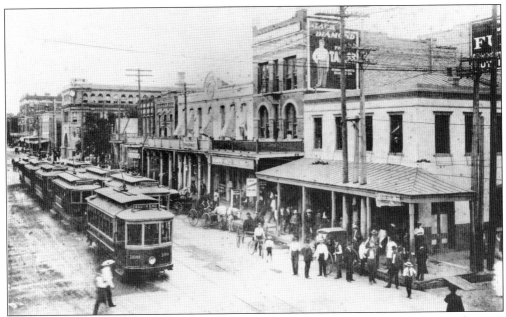

This view, dating to about 1910, looks north up Travis Street between Texas Avenue and Prairie Street. Car 166 and 155, purchased in 1902–1903, seem to be leading a parade of Houston's modern electric streetcars. The banners on their sides suggest it may have been a special excursion. (Courtesy HMRC, HPL.)

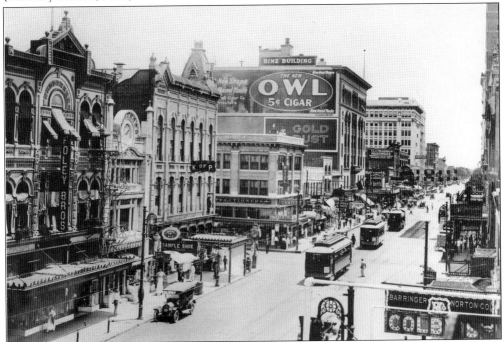

This view, looking south down Main Street about 1915, shows how fast Houston was booming. Streetcars already had to contend with automobiles, and the six-story Binz "skyscraper" had been surpassed by several buildings, including the eight-story Kress Building at Main Street and Capitol, and the new 17-story Rice Hotel. (Courtesy HMRC, HPL.)

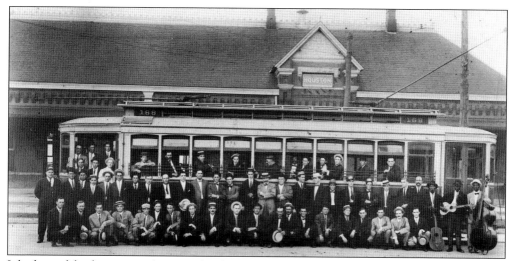

It looks as if this business junket, posed in front of their chartered streetcar at the International and Great Northern depot on Congress Avenue about 1920, has brought their own band. Chartering streetcars to local or visiting groups for prearranged trips was an extra source of income for the company. (Courtesy HMRC, HPL.)

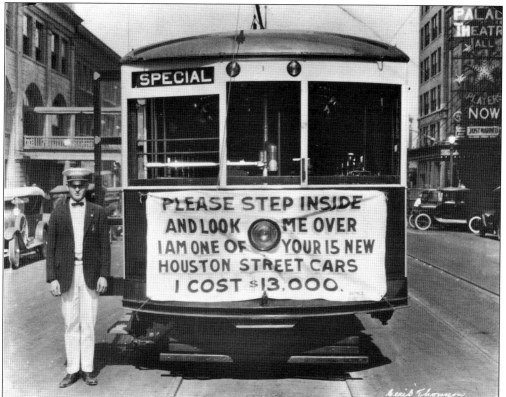

Faced with the growing number of automobiles and the competition of jitneys, in September 1924, the Houston Electric Company launched an advertising campaign inviting Houstonians to come and investigate their modern, new $13,000 Birney streetcars, but they were already fighting a losing battle. (Courtesy HMRC, HPL.)

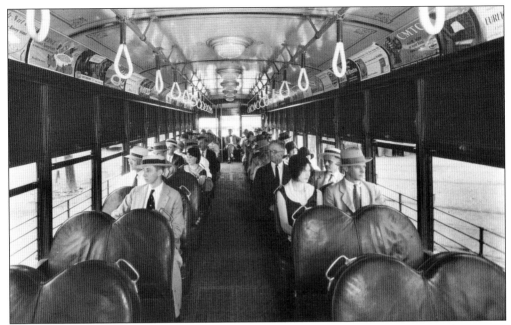

This is the interior of car No. 406, perhaps the one in the previous photograph. The roomy, upholstered seats, light colors, electric ceiling lights, and linoleum flooring were a sharp contrast to the older cars with their hard, wooden seats, providing the perfect setting for these fashionable ladies and gentlemen in their straw fedoras and boaters. (Courtesy HMRC, HPL.)

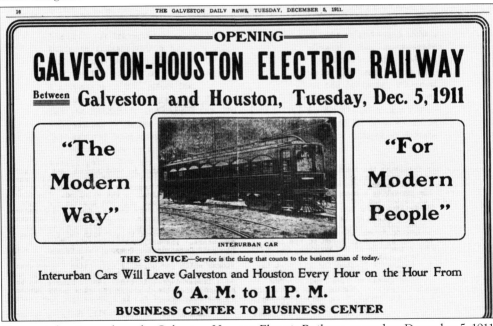

Houston's first interurban, the Galveston-Houston Electric Railway, opened on December 5, 1911, with runs "on the hour, every hour," leaving both cities from 6:00 a.m. until 11:00 p.m. Each trip took 100 minutes, shortened to just 90 minutes in 1924. Terminals were located on Main Street across from the Rice Hotel in Houston and on Twenty-first Street between Church and Postoffice Streets, in Galveston. (Courtesy, Texas Room, HMRC, HPL.)

THE TANGENT

Vol. 1 **April, 1912** **No. 5**

GALVESTON

Spring Number

7

Stone and Webster, the electrical engineering company that built GHE, published this monthly magazine to promote it and the Houston and Galveston streetcar lines, which they also owned. The name *Tangent* comes from the fact that the line was completely straight from the outskirts of Houston to the Galveston Causeway. After World War I, runs were added at 5:00 a.m. and midnight, and the schedule expanded with express trains called *Galveston Flyer* and *Houston Rocket*. GHE also added extra runs every year during the summer season to cater to those wishing to escape the heat in Galveston. The *Pleasure Limiteds* ran directly to the beachfront. These were beautiful wooden cars nicknamed "bluebirds," painted blue and white with the picture of a bluebird on the side and encircled with the motto "Speed with safety." (Courtesy, Texas Room, HMRC, HPL.)

THE TANGENT

Vol. 1 May, 1912 No. 6

This image evokes GHE's special late-night limiteds, the *Moonbeam* and the *Nighthawk*, which left the beachfront at 11:00 p.m. and midnight. Stone and Webster paid a quarter of the construction costs of the causeway seen here. The GHE was built to extremely high standards, and while the lack of curves and grades saved some costs, the causeway construction was expensive and proved to be a burden on the road's financial status later. The convenience of the automobile and then the Depression took their toll on ridership, and the last run to Galveston was made in 1936. (Courtesy Texas Room, HMRC, HPL.)

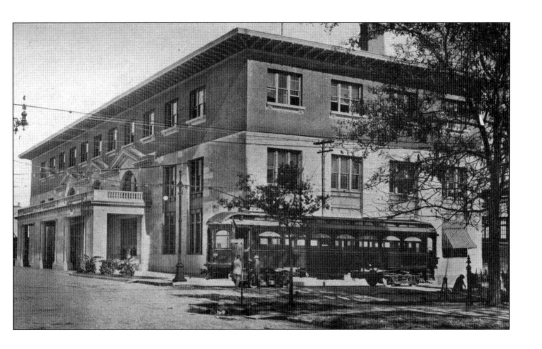

The GHE soon moved its passenger station in Houston to the corner of Texas Avenue and Milam Street, but as the interurban made its way out of town, it also stopped at Union Station. Over the years, more runs with different schedules would be implemented, with some express runs taking only 75 minutes. Suburbs, like Park Place and South Houston, boomed along the interurban, and in the mid-1920s GHE added local runs to serve them. The Houston North Shore Railway (below) was Houston's "other" interurban. It also stopped at Union Station, but passengers boarded on Prairie Street, across from the HB&T freight depot. The cars ran out Liberty Road to Lyons Avenue, to HNS tracks at McCarty Drive. (Above courtesy Texas Room, HMRC, HPL; below courtesy Paul DeVerter.)

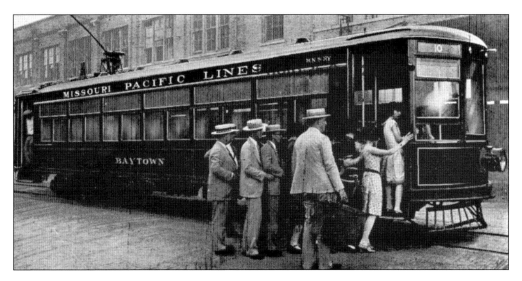

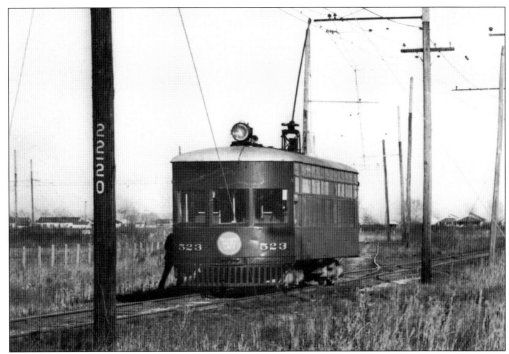

Four "lightweight" cars numbered 523–526 were the first new cars purchased for HNS in April 1927 from the American Car Company, just in time for the new interurban line to open that May. This photograph of No. 523 shows the typically flat, rural east Harris County terrain that the North Shore crossed between Houston and Baytown. (Courtesy HMRC, HPL.)

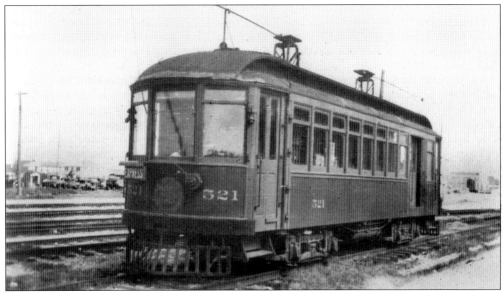

The first electric passenger cars on the line were two wooden coaches built in 1902 and purchased secondhand from an Ohio interurban. In addition to providing passenger service, HNS also had a lucrative mail and express business. No. 521 was converted into HNS's second express car by adding a baggage door and iron bars over the windows to protect them against shifting freight at the I–GN shops in Palestine in 1930. (Photograph by H. J. Heaney, courtesy Paul DeVerter.)

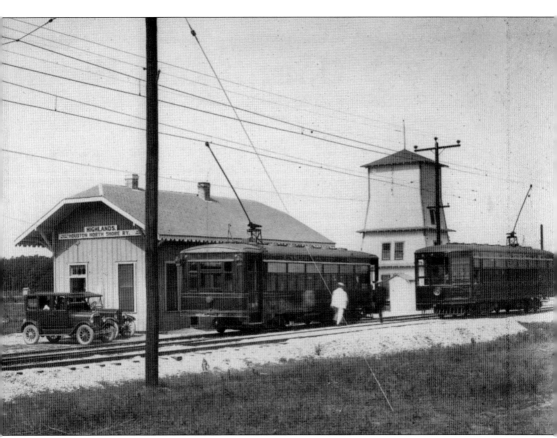

The Houston North Shore was the dream of land developer Harry K. Johnson, who hoped to profit from industrial and residential development along the north shore of the Houston Ship Channel. HNS was Houston's blue-collar interurban, connecting Houston with rural communities like Highlands and industries like the Humble Oil Refinery in east Harris County. The HNS counted on hauling freight and workers to serve the growing industrial economy, especially Humble Oil. Even its cars were more utilitarian and lightweight, painted "coach green" and fitted with screens on the windows to protect against the thick and ravenous mosquitoes. "Missouri Pacific Lines" would soon be added to their letterboards, indicating that HNS had been purchased by MP. Two of the lightweight HNS cars—No. 526, *Goose Creek*, and No. 525, *Baytown*—are shown passing the Highlands depot and the square water tower Johnson built. His land office was located on the first floor. (Courtesy Paul DeVerter.)

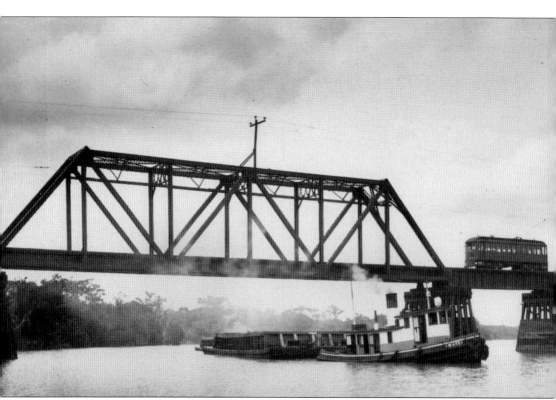

Although the North Shore interurban had to cross several bayous and creeks, including Goose Creek, Hunting Bayou, and Greens Bayou, the major construction hurdle was crossing the San Jacinto River. Because the river was navigable, the bridge had to be 25 feet above water level. This was done on a 160-foot steel-through-Warren-truss bridge flanked by two 54-foot deck girder bridges on the east and four on the west. Approaches over the marshy river flood plain on both sides were on creosoted pilings. At 4,379 feet, it was said to be the longest railroad bridge in Texas at the time. On November 22, 1926, Johnson had invited the Houston Chamber of Commerce to inspect his construction project. They were driven to the west bank of the river, where they could see the progress being made on the bridge, and the 51 gentlemen were treated to a fried chicken dinner prepared by Mrs. Johnson and other ladies. This view of the bridge shows one of the first HNS cars approaching the Warren truss span. (Courtesy Paul DeVerter.)

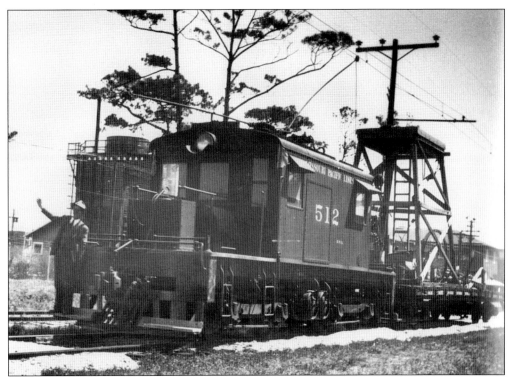

The North Shore delivered freight as well as passengers. No. 512, a Baldwin-Westinghouse 50-ton, 400-horsepower locomotive, was purchased new in 1927, and performed that task until wartime demands required steam locomotives to take over in 1942. She could pull 35 cars at an average speed of 10 miles per hour, although she was capable of safely doing 35 miles per hour. Here No. 512 was helping with a line repair. (Courtesy Paul DeVerter.)

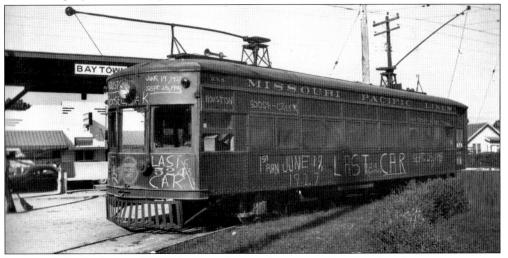

For years, MP, which owned HNS, had been looking for ways to eliminate electric passenger service. Electric service had already ended into downtown with the elimination of the Lyons Avenue streetcar line in September 1931, and service was cut back to McCarty Street. MP experimented with rail buses, and on September 24, 1948, it was learned that the last interurban cars would run the next day. (Courtesy Paul DeVerter.)

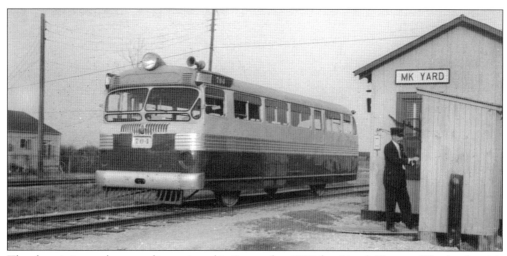

The electric interurban was discontinued in September 1948, but North Shore still had to furnish daily passenger service between Baytown and Houston. Rail buses were cheaper to operate because they did not require expensive electrical overhead wires and because of the low cost of gasoline. They ran to MK Yard on McCarty Avenue, where passengers transferred to buses for the trip to Union Station. (Courtesy TRHM.)

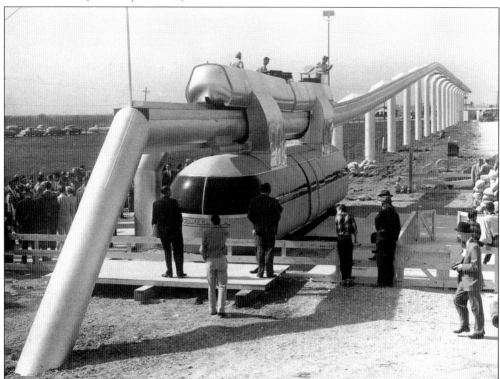

In 1955, a prototype monorail system was put on display at Arrowhead Park, off South Main Street. It was called the "Trailblazer," powered by 310-horsepower Packard engines. The driver rode in a bogie above the passenger cars. Reports are that 6,000 persons rode it, but city officials were uninterested. It was dismantled and taken to the state fairgrounds in Dallas. (Courtesy HMRC, HPL.)

Five

PASSENGER OPERATIONS

With the opening of Union Station in 1911, passenger service was concentrated at four depots. This was reduced to three in 1925, when the I&GN moved their trains to join the Gulf Coast Lines (Missouri Pacific) and Santa Fe at Union Station. The Southern Pacific had already concentrated their lines at Grand Central Station on Washington, and the Missouri, Kansas, and Texas had their little depot almost right between them, off the Main Street Viaduct.

At one time, over 60 trains a day linked Houston with every major city in Texas and most in the nation and thousands of small towns in between. Accommodations varied from slow mixed trains that provided freight and express service to every community along the route to "extra fare" trains, offering speedy, luxurious comfort with few stops. Galveston was served by the Santa Fe's *California Special*, the *Ranger*, and the *Texas Chief* and unnamed MP and SP trains. To Dallas, there were the *Sunbeam*, the *Hustler*, the *Sam Houston Zephyr*, and the *Owl* as well as the *Katy Flyer*, *Texas Special*, and *Bluebonnet* at different times. To Fort Worth, there were the *Texas Chief*, *Ranger*, and the *Texas Rocket*, later *Twin Star Rocket*. The *Sunset Limited*, the *Argonaut*, the *Orleanean*, and the *Acadian* ran to New Orleans daily. Many routes offered coaches and sleepers that were transferred from one train to another en route, providing accommodations from Clovis to New Orleans and from Brownsville to New York, for example, connecting Houston with an almost unlimited number of destinations.

After World War II, Houston's passenger train service climaxed in a swan song of beautiful, streamlined, diesel-powered blue-and-gray *Eagles* and silver-and-red *Texas Chiefs* and *Sunset Limiteds*. Providing faster than ever service in brand-new multimillion dollar train sets, they put up one last futile fight against the convenience of the interstate and the speed of the jetliner. Finally, in 1971, Amtrak took over. The *Texas Chief* would strive a few more years, being renamed and finally falling victim to Amtrak budget cutbacks in 1979, leaving Houston served only by Amtrak's version of the *Sunset Limited*, three times a week in each direction.

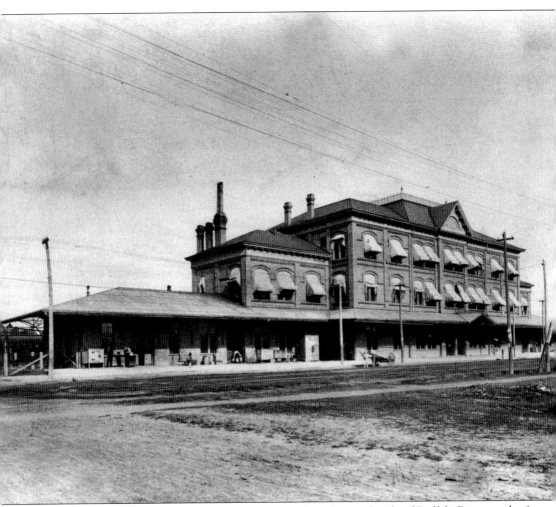

The grandly styled Grand Central Station located on the north side of Buffalo Bayou at the foot of Washington Avenue, where the Amtrak station is now, was probably the Houston and Texas Central's third depot in this location and was built in the late 1880s as the Southern Pacific was consolidating its holdings in Texas. As the busiest depot on the Texas and Louisiana Lines, with 44 trains arriving every day by the mid-1920s, it would serve the SP's passenger operations here until the new art deco–style Grand Central opened in 1934. (Courtesy Texas Room, HMRC, HPL.)

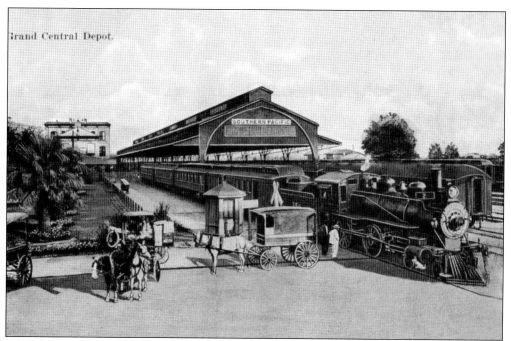

Many larger 19th-century depots were built with "train sheds," tall, intricate structures, usually of iron, covering the tracks to protect travelers from the weather. This *c.* 1900 postcard shows an eastbound passenger train emerging from Grand Central's train shed, with a tropical-themed park area on the left. (Courtesy HMRC, HPL.)

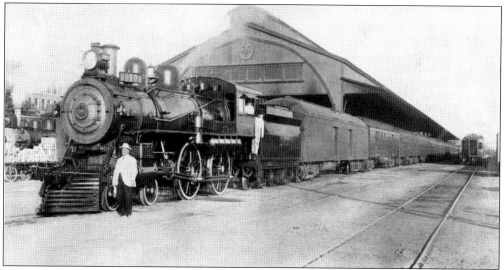

Here is the eastbound *Sunset Express*, featured in a book titled *Oil Fuel*, which the Texas Company published in 1912 promoting the use of oil as locomotive fuel. Southern Pacific's lines in Texas were already enthusiastically moving in that direction, as evidenced by oil-burning No. 263, a handsome E-23 class 4-4-0 built by Cooke in 1900 for the T&NO, on the point. (Courtesy Texas Room, HMRC, HPL.)

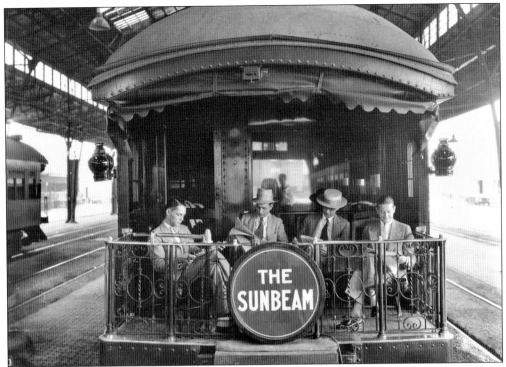

These cool gents are perched on the rear platform of Texas and New Orleans's new deluxe nonstop train, the *Sunbeam*. It is almost noon, departure time for the train, on an August day in 1928, and the train shed is protecting the train and its passengers as much as possible from the Texas sunshine. (Courtesy HMRC, HPL.)

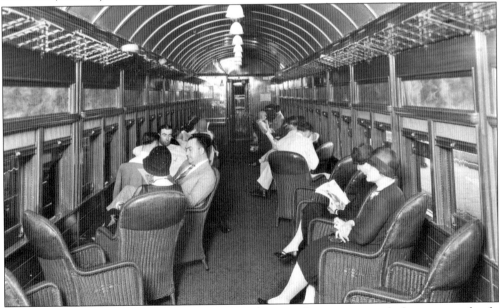

Inside the *Sunbeam*'s parlor-observation car can be seen the roominess, plush carpet, and soft, comfortable, movable chairs that were the amenities reserved for extra fare. After a brisk ride, at speeds up to 55 miles per hour, they will arrive in Dallas by 6:30 p.m. (Courtesy HMRC, HPL.)

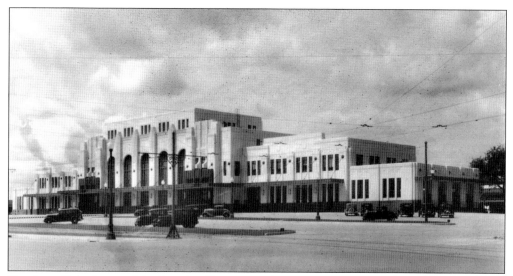

Coming off the boom of the Roaring Twenties and anticipating continued growth in passenger operations, Southern Pacific decided to replace its aging and outgrown station. The new Grand Central was a very modern facility, built at a cost of $4,347,000, with 10 station tracks that could be accessed through a "subway" from the head house. There was a Railway Express Agency, post office, and room for the railroad's Houston division offices. But by the time it opened on September 1, 1934, the Depression was in full swing. Grand Central was the last major passenger depot built in Texas. Passenger traffic would briefly boom during World War II but would never return to the level of the 1920s. (Both courtesy HMRC, HPL.)

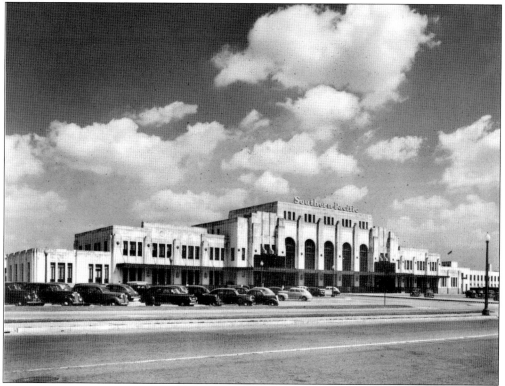

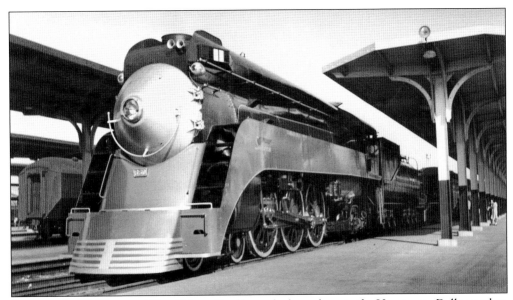

For years, the SP (Texas and New Orleans) had been the lone player in the Houston-to-Dallas market, but in 1936, the Burlington introduced one of their diesel streamliners called the *Sam Houston Zephyr*, and it ushered in sharp competition that was to last for 20 years. The photograph above shows train No. 13, the *Sunbeam*, threading its way out of Grand Central in the August afternoon sunshine at 4:45 behind P-14 No. 650. The bottom photograph was taken the same summer, but No. 651 was on the point this time, really hitting her stride as she blasted through Eureka Junction on her "mile-a-minute" run, arriving in Dallas at 9:10. (Above photograph by R. S. Plummer, Gordon C. Bassett Collection, courtesy Joel Rosenbaum; below courtesy HMRC, HPL.)

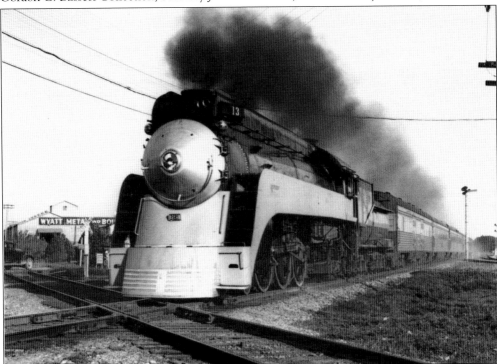

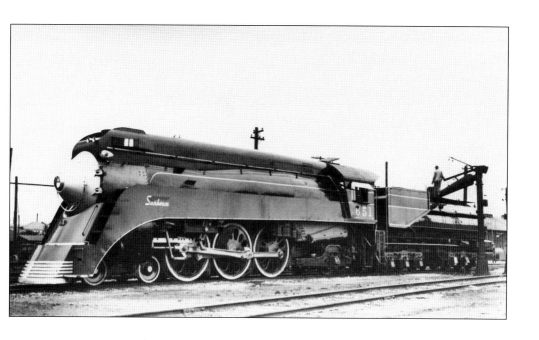

In 1937, the T&NO leased three P-6 class locomotives, built in 1913 by ALCO-Brooks for the Hardy Street Shops to rebuild. The result, T&NO P-14 class streamlined Pacifics, Nos. 650–652, have been called "the most beautiful . . . locomotives to have ever operated in Texas." No. 651 is shown here taking on water at Houston in April 1938. For 25 years, they kept a "double daily" of beautiful streamliners, the *Sunbeam* and the *Hustler*, flying between Houston and Dallas at a sustained 75 miles per hour. No. 652 is shown below speeding through Waller, on the point of train No. 15, the *Hustler*, which ran on a schedule opposite the *Sunbeam*'s, leaving each city at 8:00 a.m. and arriving at 2:00 p.m. (Both photographs by Harold K. Vollrath, courtesy Joel Rosenbaum.)

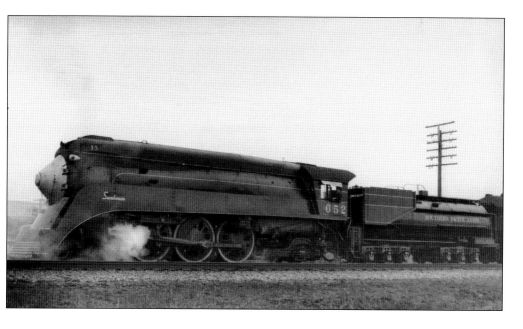

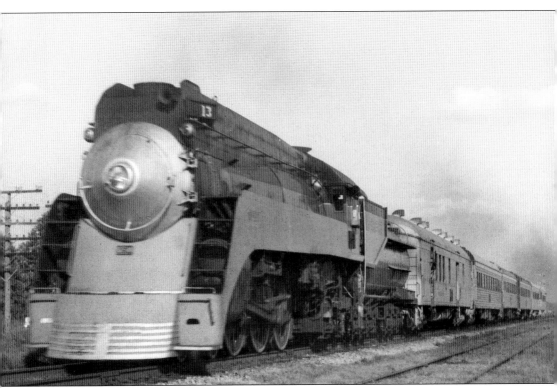

Beginning in 1938, thanks to newly upgraded signals and trackwork, the Sunbeam could advertise a schedule of "265 miles in 265 minutes," in spite of the fact that a two stops were required for railroad purposes and a passenger stop was added at College Station. The new, air conditioned Pullman-Standard streamlined cars offered amenities that the Zephyr could not match: roomy, comfortable seating in the chair cars, plush carpeting and swivel chairs in the parlor car, and a full service diner-observation, complete with a classic round-end. This photograph, taken in June 1953 shows No. 650 flying out of Houston. Twenty-five years after her re-building she is still as beautiful as ever, in her splendid Daylight livery of orange, red and black, with silver accents. Over time the cars, including the Harriman style Railway Post Office, have lost their matching colors, being repainted in the Sunset Limited's silver with red letterboards, but they still carry the distinctive Sunbeam herald on their sides. In October the steam engines will be replaced by ALCO PA's. Sadly, No. 650 will face the torch next March. (Courtesy Joel Rosenbaum.)

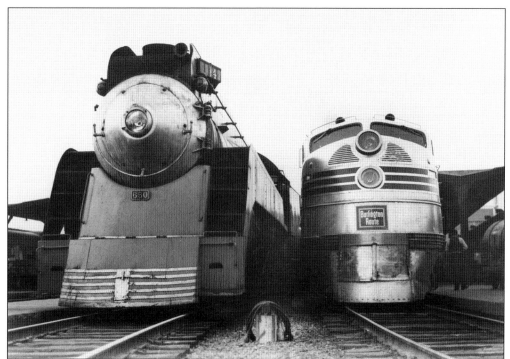

There was a race of iron horses every evening from September 1937 until the final run of the *Sunbeam* in 1955. At 5:00, both the *Sunbeam*, for most of those years powered by her beautiful P-14 Pacifics, and the *Sam Houston Zephyr*, powered in this photograph by Fort Worth and Denver E-5 No. 9909, set off on their mile-a-minute dash for Houston. (Photograph by R. S. Plummer, Gordon C. Bassett Collection, courtesy Joel Rosenbaum.)

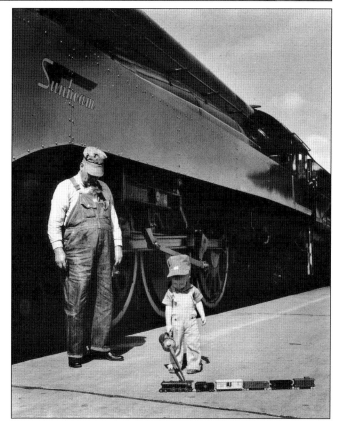

This publicity photograph appeared on the cover of the May 1938 *Texas and Louisiana Lines Bulletin*. The engineer was identified as C. Rowland and the little tyke with the train as William Ross Olive. This pose was used to promote their West Coast *Daylights* as well as the new *Sunbeam*. (Courtesy HMRC, HPL.)

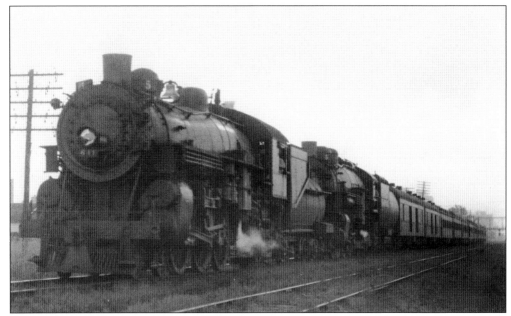

The westbound *Argonaut*, train No. 5, is seen here entering Houston on a foggy morning in March 1948, being double-headed by two Pacific 4-6-2s. The *Argonaut* covered the same route as the *Sunset Limited* but with a slower schedule, carrying more express and mail. It was considered a more modest train, making more stops and providing more economical transcontinental service with sleepers, dining cars, and coaches. (Harold K. Vollrath Collection, courtesy Joel Rosenbaum.)

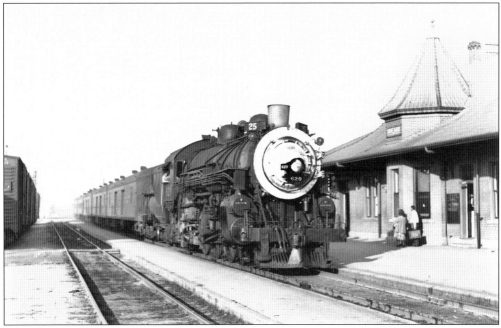

Here one can see the SP's local train No. 25, the *Rabbit*, behind venerable P-6 class Pacific T&NO 620, which was built by ALCO-Brooks in 1913. When this classic photograph was taken in Lufkin in 1953, No. 620 was 40 years old and still beautiful. But this local would come to an end in August 1954. (Courtesy TRHM.)

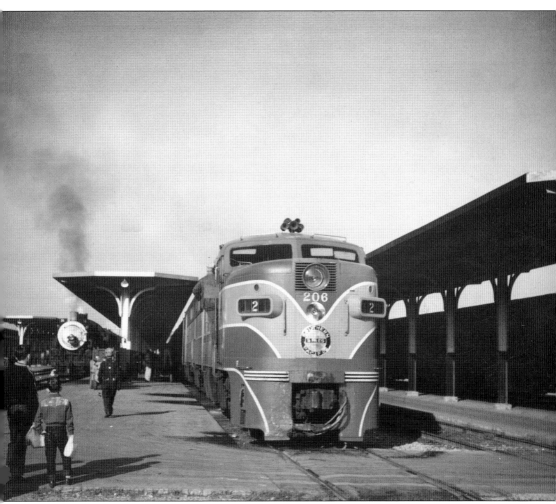

The *Sunset Limited* was T&NO's premier train, daily connecting Houston with New Orleans and Los Angeles on an unprecedented 42-hour schedule. The SP had paid the Budd Company $15 million for five new train sets, delivered in August 1950. The "French Quarter" lounge car with its watermelon-red ceiling and "Audubon" dining car, featuring artwork of its namesake and serving Southern cuisine, honored the Sunset Route's roots in Texas and Louisiana. No. 2 was photographed about to depart Grand Central Station for New Orleans at 8:40 on a beautiful April morning in 1954. A passenger just boarding could have enjoyed a rich cup of coffee and perhaps a sandwich later in the "Pride of Texas" coffee shop car, and been in New Orleans by 4:00. Returning, he would leave at half past midnight and arrive in Houston at 7:30 the next morning after a restful night's sleep. The ALCO PAs providing the power would have been serviced in New Orleans, turned around, and brought the train back to Houston the next day. (Photograph by Joe Thompson, courtesy TRHM.)

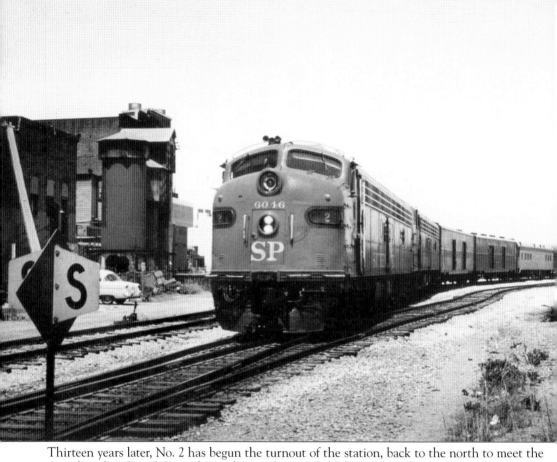

Thirteen years later, No. 2 has begun the turnout of the station, back to the north to meet the main line, but Grand Central is no longer there and the *Sunset* is no longer "limited" except in service. By the time SP put the new Budd train sets in service, the tide had already started to turn against train travel, and SP never entertained the same romantic attachment to preserving the image that some roads did. When revenues started to plunge, they lost little time cutting losses. The *Hustler* and *Rabbit* were eliminated in 1954, the *Sunbeam* the next year, and the *Argonaut* in 1963. The *Sunset* is seldom on time, and the diner and lounge have been replaced with an "Automat car." The last source of revenue, mail and express contracts, would be lost this year. In October 1970, SP agreed to restoring the diner, lounge, and sleepers if allowed to reduce the train to a tri-weekly schedule, which was inherited by Amtrak and continues today. (Photograph by Joe Thompson, courtesy TRHM.)

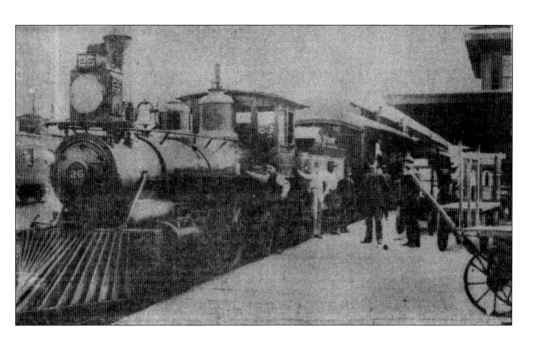

The undated photograph above is from the *Houston Chronicle*'s "Watchem" section in response to a question about the International–Great Northern Depot that once stood on Congress Avenue in the same location as Allen's Station, shown on the bottom of page 20. Missouri Pacific moved passenger operations to Union Station in 1925 after gaining control of the I–GN. The last passenger trains to leave from here were commuter trains that transported workers to Ship Channel industries during World War II. By 1955, when George Werner photographed HB&T No. 16 rumbling by below, the lovely, yellow, brick late-Victorian station had been reduced to storage and office space. (Above courtesy Texas Room, HMRC, HPL; below courtesy George C. Werner Collection.)

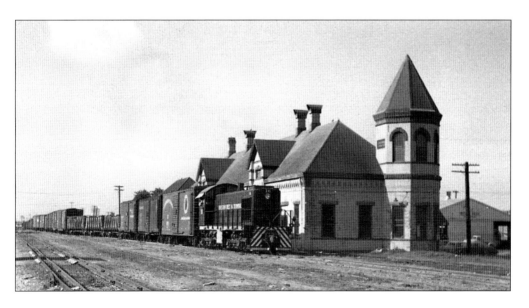

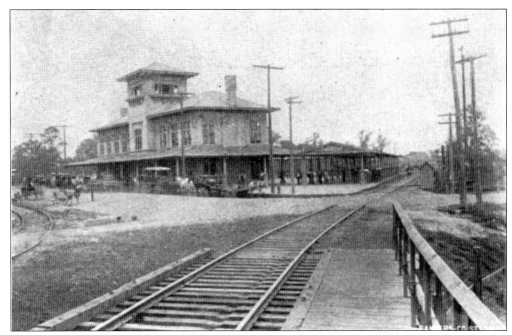

The Missouri, Kansas, and Texas Railroad built their own line into Houston in 1893 and opened this very modern depot on White Oak Bayou just north of Buffalo Bayou. In this image, the photographer is looking northwest from the bridge over White Oak. (Courtesy Texas Room, HMRC, HPL.)

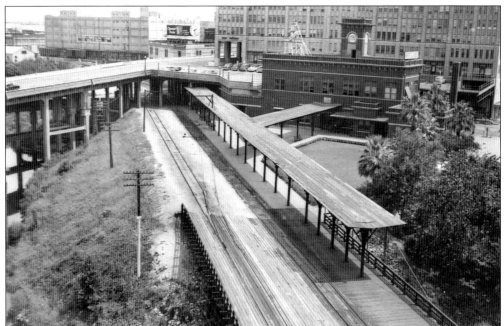

This aerial view of the Katy's bi-level depot, looking south, shows very well how it was oriented just off the Main Street Viaduct over Buffalo and White Oak Bayous. White Oak Bayou is to the left. The large building looming behind the depot is the Merchants and Manufacturers Warehouse, or M&M Building, now University of Houston, Downtown. (Courtesy TRHM.)

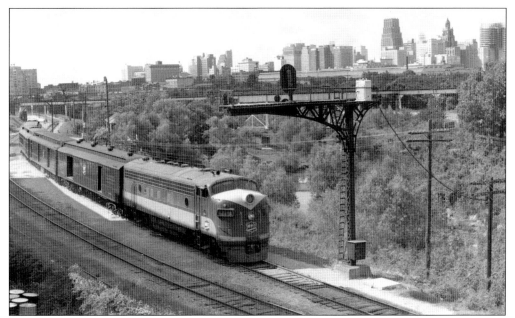

Two of the things that made passenger train travel so special were the colorful trains and their romantic names. The *Bluebonnet*, train No. 22, has just left the little Katy depot and is gliding along White Oak Bayou on her way north to Waco, Fort Worth, and Denison, with bright-red E-7 No. 101 and the dark-green heavyweight cars shining in the morning sun. (Photograph by Joe Thompson, courtesy TRHM.)

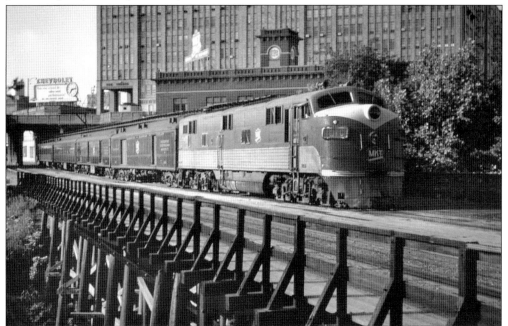

The northbound Katy *Bluebonnet* seen here in May 1957 is typical of the basic transportation supplied by many passenger trains. With her usual consist of two baggage cars, a chair car, and a coach, No. 22 will leave Houston at 8:30 this morning and arrive in Fort Worth at 5:00, for an average speed of about 39 miles per hour. (Courtesy George C. Werner Collection.)

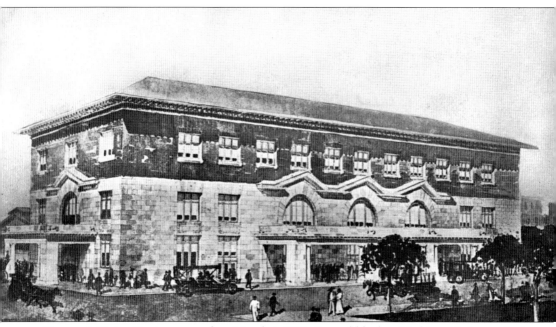

Houston's Union Station opened on March 1, 1911. Several blocks of fashionable homes had to be razed to make room for the passenger terminal on the eastern edge of the business district. Designed by the firm of Warren and Wetmore, collaborators on New York's Grand Central, it was built by the Houston Belt and Terminal Railway at a cost of $5 million. (Courtesy Texas Room, HMRC, HPL.)

Located at the corner of Texas Avenue and Crawford Street, Union Station was the largest passenger terminal in the Southwest and immediately became a major center of activity, with a Railway Express office and also a stop on the Galveston-Houston Interurban. For three quarters of a century, it stood as a landmark. (Courtesy Gulf Coast Chapter, NRHS.)

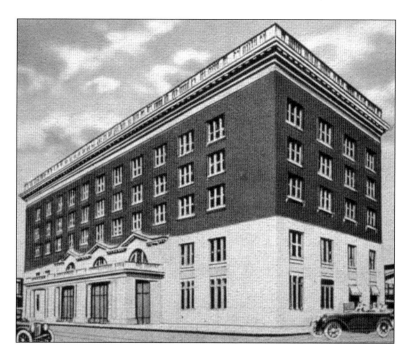

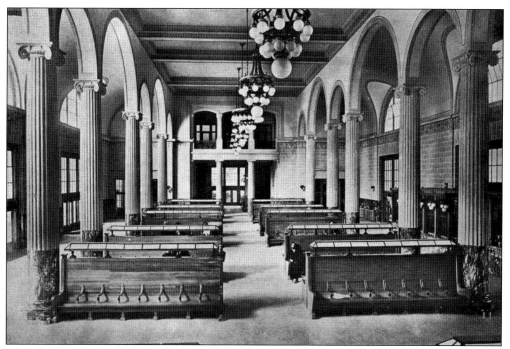

This photograph of Union Station's main waiting room was probably taken just before its opening. It shows the large, light, and airy open space, massive classic columns, and arches suggestive of New York's Grand Central Station and fitting Houston's role as a prosperous, growing city and major rail center. (Courtesy Texas Room, HMRC, HPL.)

In the early 20th century, railway stations were probably the most public spaces that ladies routinely visited. They were exciting, busy, noisy places that required a quieter, protected area for ladies—thus we have the separate Ladies Room, where ladies might retire while waiting to board their train. (Courtesy Texas Room, HMRC, HPL.)

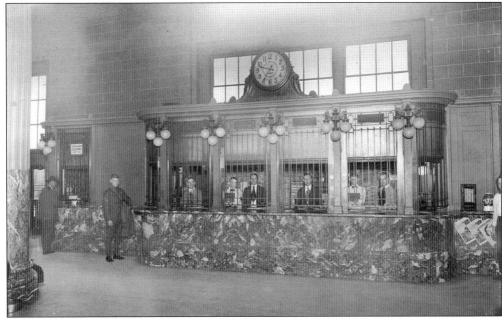

This was the ticket window, located in the main waiting room just across from the main entrance, where most travelers purchased their tickets the day of travel. Detailed and well-planned reservation systems made it possible to purchase a round-trip ticket for almost any place on the continent right here. (Courtesy Gulf Coast Chapter, NRHS.)

Union Station was built as a "stub end terminal" with individual sheds between each track. This was the station concourse, a large covered area connecting the "head house" or main building with the covered platforms along the tracks that ran perpendicular to the view here. The Lunch Room was across from the Ladies Room. (Courtesy Texas Room, HMRC, HPL.)

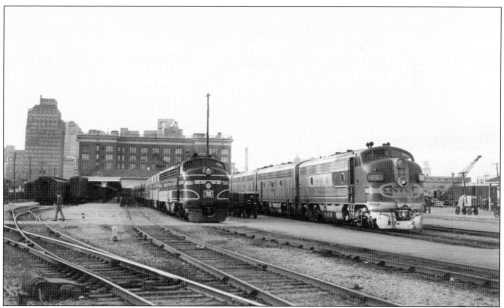

Union Station's passenger boarding tracks were perpendicular to the building and actually ended at it, as seen here. Trains did not just stop next to the depot and then move on once passengers boarded, but instead backed in and then pulled out to leave, as was fitting for a major rail center. (Photograph by Joe Thompson, courtesy TRHM.)

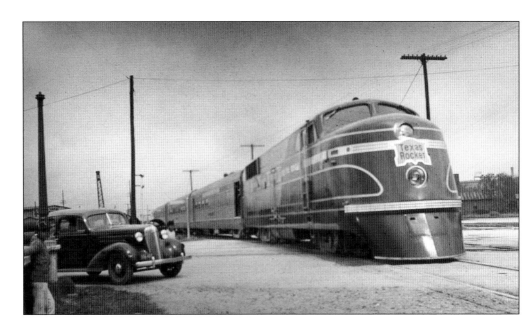

In 1936, Burlington began a streamlined service between Houston and Dallas using *Zephyr* diesel No. 9901, called the *Sam Houston Zephyr*, and nine months later, Rock Island added the *Texas Rocket* on a complementary schedule, using a TA locomotive as seen in the photograph above. The next year, *Zephyr* diesel No. 9902 took over on the *Rocket*, the two trains running their own daily double against the T&NO's *Sunbeam*. In 1944, *Sam*'s power car was irreparably damaged in a fire, and the next year, the *Rocket* was moved to another route. The *Sam Houston Zephyr*, with E-5 No. 5505, is seen leaving Union Station in October 1952 below. (Above courtesy TRHM; below photograph by Charles H. Kiefner, courtesy George C. Werner Collection.)

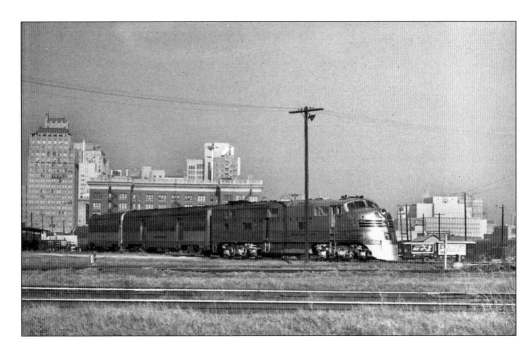

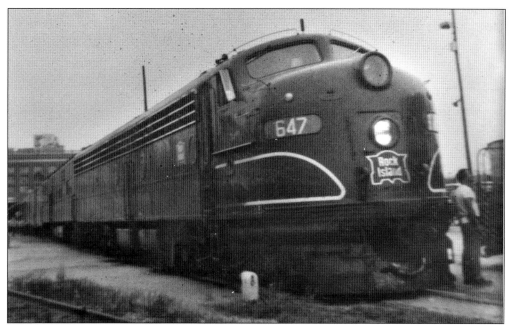

Rock Island's *Twin Star Rocket* was inaugurated in January 1945, succeeding the *Texas Rocket*'s run from Houston to Fort Worth. The *Twin Star* continued on from Fort Worth to Minneapolis. Led by E-8 No. 647, the *Twin Star Rocket* in the above photograph will be leaving Union Station at 5:00 p.m., covering the 1,363-mile route in 25 hours and 40 minutes with 26 scheduled stops. In the photograph below, she is shown about to enter the wye to back into Union Station. A typical consist would have included chair cars named *Houston* or *Fort Worth*, a diner named *Ocotilla*, and sleepers named *Buffalo Bayou* or *San Jacinto*, which would be set off at Kansas City. (Above photograph courtesy Phil Whitley; below photograph by R. S. Plummer, Gordon C. Bassett Collection, courtesy Joel Rosenbaum.)

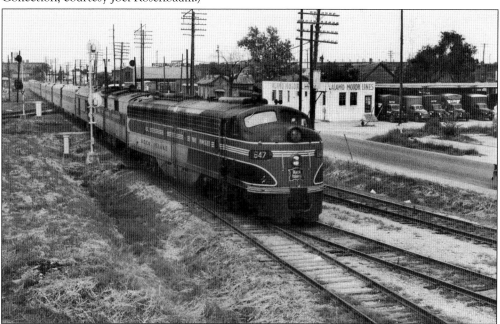

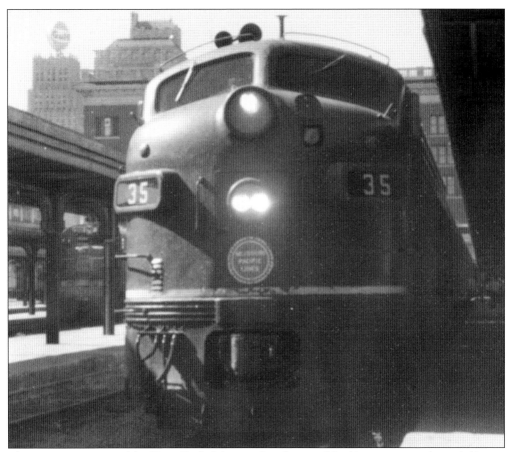

The Houston section of the *Texas Eagle*, Missouri Pacific train No. 42, is preparing for its 3:40 p.m. departure from Union Station. In Palestine, Texas, she will meet the San Antonio section and then in Longview, the Fort Worth/El Paso section, to continue as train No. 2, the *Texas Eagle*, and arrive in St. Louis the next morning at 8:30. The *Texas Eagle* offered through connections to the East Coast. The photograph below is of the *Eagle Oak*, a 10-roomette, 6–double bedroom sleeping car owned by the Pennsylvania Railroad. One could board the *Penn Texas* in New York or Washington, D.C., and have a direct train ride to any place Texas served by the *Texas Eagles*. (Above photograph by Phil Whitley, courtesy Gulf Coast Chapter, NRHS; below photograph by George E. Votava, courtesy Joel Rosenbaum.)

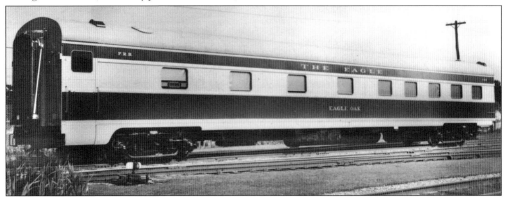

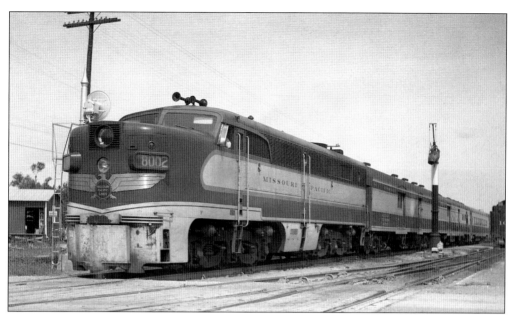

Both these MP trains, with their baggage/express and RPO cars on the head end, are good examples of how passenger trains connected communities, big and small, with the world, carrying mail and express as well as people. The *Valley Eagle* (above) left Houston at noon, arriving in Brownsville at 8:25 p.m., for an average speed of about 42 miles per hour. Below, the *Houstonian*, an all-stops local which left New Orleans the night before at 10:10, is approaching Union Station at 8:00 on the morning of March 8, 1952. For many years, the *Houstonian* carried Santa Fe connecting sleepers for New Orleans. There was no explanation for the presence of the 4-6-2 Pacific. Perhaps the diesel may have had mechanical trouble along the way. (Both photographs by Charles H. Kiefner, courtesy George C. Werner Collection.)

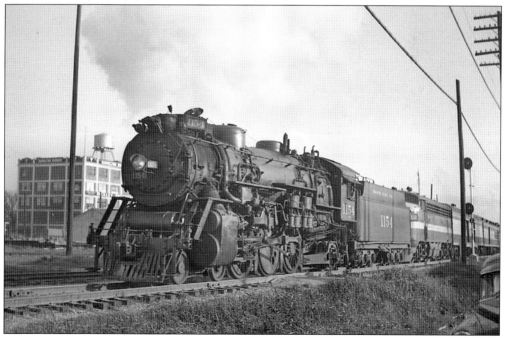

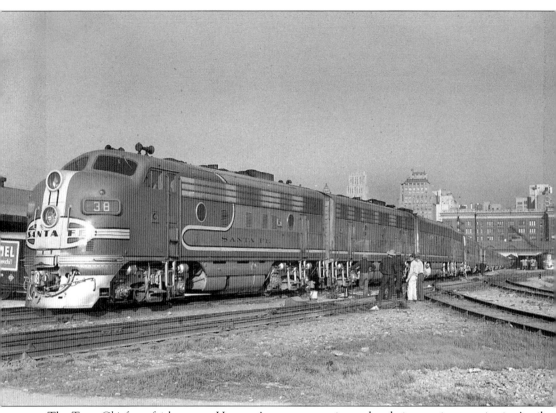

The *Texas Chief* was fairly new to Houston's passenger train market, being put into service in April 1948 as part of Santa Fe's postwar streamliner expansion. No. 16 is about to depart Houston's Union Station on the morning of March 8, 1952, continuing its 1,410-mile journey from Galveston to Chicago, where it will arrive at 9:00 the next morning. Along the way, the *Texas Chief* will call at Temple, Fort Worth (with a connection to Dallas), Oklahoma City, Wichita, and Kansas City. The ABBA lash-up EMD F-3s were typical power for No. 15 and 16. Streamlined equipment would have included a railway post office car, baggage-express car, a bar-lounge-dormitory car where the crew would have slept, a Fred Harvey diner, several chair cars, and Pullmans offering compartments, roomettes, bedrooms, and drawing rooms. (Courtesy George C. Werner Collection.)

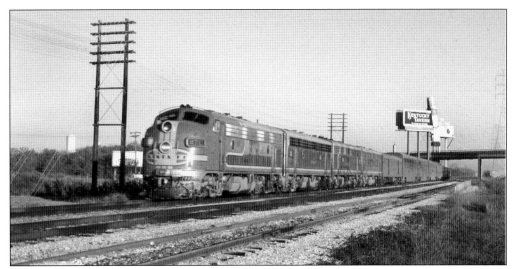

It is 16 years later, and many of the best passenger trains are only fond memories, but the *Texas Chief* is still a first-class operation all the way. Her seven-car consist includes three Hi-Level chair cars, a big dome lounge car, and a diner, but only one sleeper. Here she has just ducked under the Gulf Freeway and is skirting the University of Houston campus, along what is now Spur 5. (Courtesy George C. Werner Collection.)

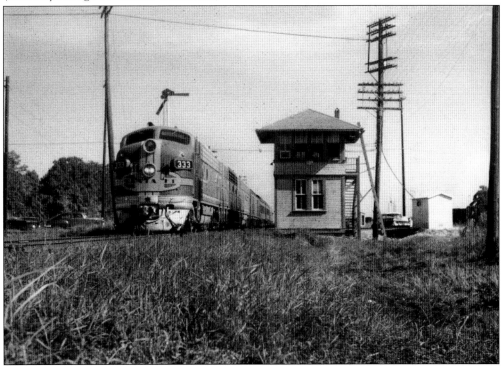

The all-stops local counterpart to the *Texas Chief* was train No. 5 and 6, the *Ranger*, which ran on a 25-hour schedule between Kansas City and Galveston, reaching Houston early in the morning. By the time George Werner shot this picture of the *Ranger* at Tower 81 in July 1956, train No. 5 was down to offering just coach and "coffee shop" amenities. (Courtesy George C. Werner Collection.)

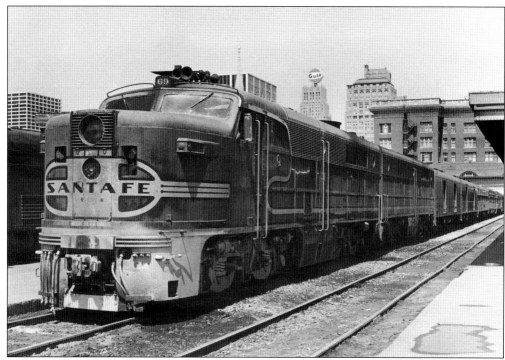

This writer's first train trip was on the *California Special* from Houston to Brownwood, but unfortunately, my only memory is how much I enjoyed the water cooler at the end of the car. The *Special* was another of those trains with frequent stops, serving many small towns in west Texas, but it also connected with the *San Francisco Chief* and carried connecting sleepers for the West Coast. In the photograph above, No. 65 has just arrived from the west, and her ALCO PA has the coating of dust to show it. Below, the westbound *California Special* just arrived at Rosenberg's Union Station at 7:37 p.m. (Above courtesy Gulf Coast Chapter, NRHS; below courtesy George C. Werner Collection.)

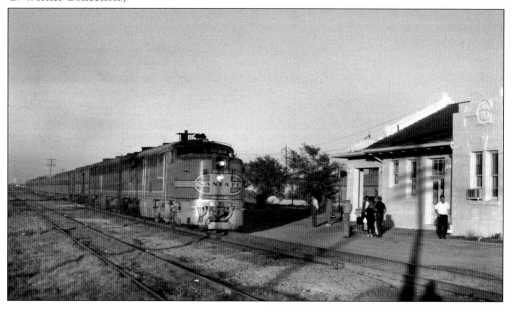

In 1959, SP razed Grand Central Station to make room for the new Central U.S. Post Office and built this squat, minimalist depot in about the same place as the 1888 Grand Central. All that remains from the 1934 depot are the butterfly station platforms. Amtrak's No. 1 westbound *Sunset Limited* stops here Monday, Wednesday, and Friday evenings, and eastbound No. 2 early on Sunday, Tuesday, and Friday mornings. (Photograph by the author.)

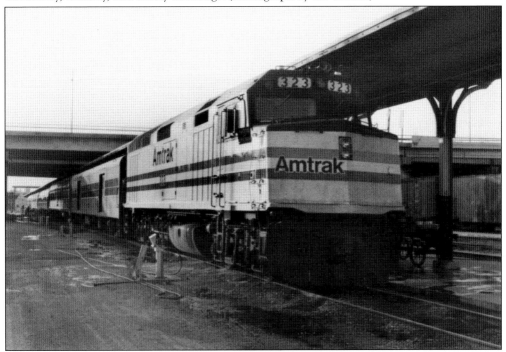

In August 1974, Amtrak consolidated operations at the SP Depot on Washington. The train seen here on a rainy Houston morning has been renamed the *Lone Star*, but it still follows the *Texas Chief*'s route to Dallas and Chicago. Perhaps it is symbolic that a freeway, I-45, now runs right over the Houston Amtrak depot. The "butterfly" sheds protecting the platforms are the same ones that served the 1934 Grand Central Station. (Courtesy Phil Whitley.)

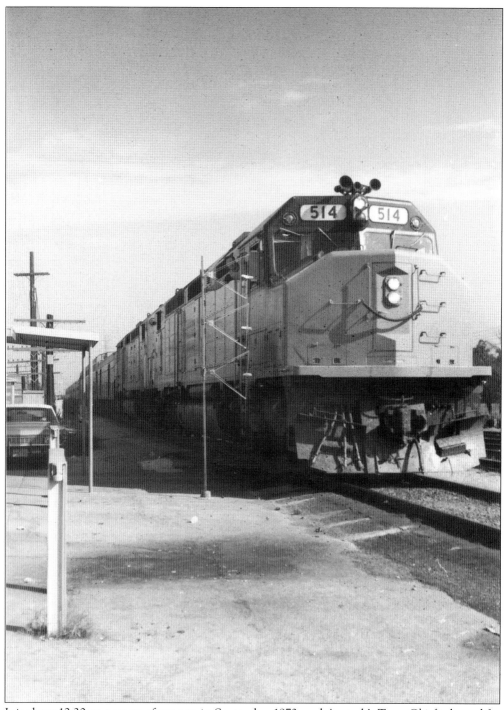

It is about 12:30 on a warm afternoon in September 1973, and Amtrak's *Texas Chief* is bound for Chicago in the roundabout way Amtrak inherited, following the historic GH&SA line to Santa Fe rails at Rosenberg. Because the train is leaving one railroad's property and entering another, the train crew must receive a new set of train orders. Here the engineer reaches out to grab his. (Courtesy Phil Whitley.)

Operating as train No. 105 until it leaves HB&T's New South Yard, the *Texas Chief* is about 10 minutes out of Union Station as one can see a historic railroading tradition played out once again. New train orders are necessary to cover the run west to Rosenberg as SP train No. 53. There the *Texas Chief* will resume her trip north as Santa Fe train No. 16. Railroads required that the engineer, conductor, and sometimes the rear brakeman each receive copies of the current train orders, called "flimsies" for the kind of paper they were written on. In these two photographs, the conductor, standing in the open doorway of an ex–Santa Fe Hi-Level chair car, and the rear brakeman, Phil Whitley, in the vestibule of the last Pullman, each reaches out from the moving train to grab his flimsy "on the fly!" (Courtesy Phil Whitley.)

BIBLIOGRAPHY

Diebert, Timothy S., and Joseph A. Strapac. *Southern Pacific Company Steam Locomotive Compendium*. Huntington Beach, CA: Shade Tree Books, 1987.

Goen, Steve Allen. *"Down South" on the Rock Island*. La Mirada, CA: Four Ways West Publications, 2002.

———. *Fort Worth & Denver Color Pictorial*. La Mirada, CA: Four Ways West Publications, 1996.

———. *Miss Katy in the Lone Star State*. La Mirada, CA: Four Ways West Publications, 2006.

———. *Santa Fe in the Lone Star State*. La Mirada, CA: Four Ways West Publications, 2000.

———. *Texas & New Orleans: Color Pictorial*. La Mirada, CA: Four Ways West Publications, 2004.

McLennan, A. D. *Texas & New Orleans: Southern Pacific's Lines in Texas and Louisiana*. Wilton, CA: Signature Press, 2008.

Reed, S. G. *A History of the Texas Railroads*. Houston: St. Clair Publishing Company, 1941.

Robinson, Charles C. and Paul L. DeVerter II. *Houston North Shore*. Chicago: Central Electric Railfans Association, 1998.

Texas State Historical Association. Handbook of Texas Online, various articles, 2008.

Werner, George C. "Railroads of the Magnolia City." *National Railway Bulletin* Vol. 4, No. 1, 1982, pp. 4–21.

Worley, E. D. *Iron Horses of the Santa Fe Trail*. Dallas, TX: Southwest Railroad Historical Society, 1965.

INDEX

DISCOVER THOUSANDS OF LOCAL HISTORY BOOKS
FEATURING MILLIONS OF VINTAGE IMAGES

Arcadia Publishing, the leading local history publisher in the United States, is committed to making history accessible and meaningful through publishing books that celebrate and preserve the heritage of America's people and places.

Find more books like this at
www.arcadiapublishing.com

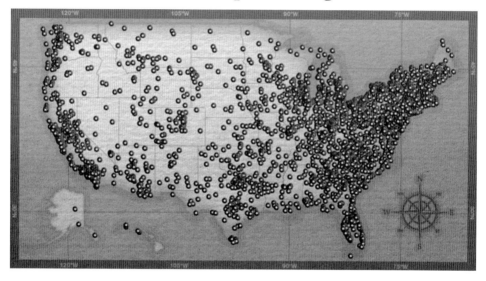

Search for your hometown history, your old stomping grounds, and even your favorite sports team.

Consistent with our mission to preserve history on a local level, this book was printed in South Carolina on American-made paper and manufactured entirely in the United States. Products carrying the accredited Forest Stewardship Council (FSC) label are printed on 100 percent FSC-certified paper.

MADE IN THE USA